Michael Katakis

PHOTOGRAPHS & WORDS

THE BRITISH LIBRARY

Books by Michael Katakis

Traveller:
Observations from an American in Exile
(Scribner / Burton and Park, 2009)

Despatches
(Foolscap Press, 2009)

Excavating Voices: Listening to Photographs
of Native Americans, (Editor)
(University of Pennsylvania Museum
of Archeology and Anthropology, 1998)

Sacred Trusts: Essays on Stewardship
and Responsibility, (Editor)
(Mercury House, 1993)

The Vietnam Veterans Memorial
(Crown Publishers, 1988)

Books by Kris L. Hardin

A Time and Place Before War: Images
and Reflections from a West African Town
(With Michael Katakis)
(Sapere Press, 2002)

African Material Culture (Co-editor)
(Indiana University Press, 1996)

The Aesthetics of Action: Continuity
and Change in a West African Town
(Smithsonian Press, 1993)

Generations (Co-editor)
(Pantheon Books, 1987)

Michael Katakis

PHOTOGRAPHS & WORDS

Additional Text and Materials by

Kris L. Hardin

Foreword by John Falconer

Introduction by Michael Palin

THE BRITISH LIBRARY

First published 2011 by
The British Library
96 Euston Road
London NW1 2DB

© 2011 Michael Katakis and Kris Hardin

Foreword © 2011 John Falconer

Introduction © 2011 Michael Palin

British Library Cataloguing in Publication Data
A CIP record is available from The British Library

ISBN 978-0-7123-0914-1

The Katakis/Hardin Archive has been generously presented to
the British Library as part of its photographic, American and
African Collections and will thus become available to future
researchers and scholars.

Book Design by Takigawa Design

Printed in Canada by Hemlock Printers

For the Librarian

who many years ago, put her arm around a frightened little boy and
walked him through the towering shelves of books and said:

*"Every word in all of these books is a thread that will weave a magic carpet that
will take you everywhere, and after you have traveled through their pages you
will find that there are more kind and open hearts than there are monsters, and
knowing that will make you less afraid."*

And

To all those who have helped us along the way

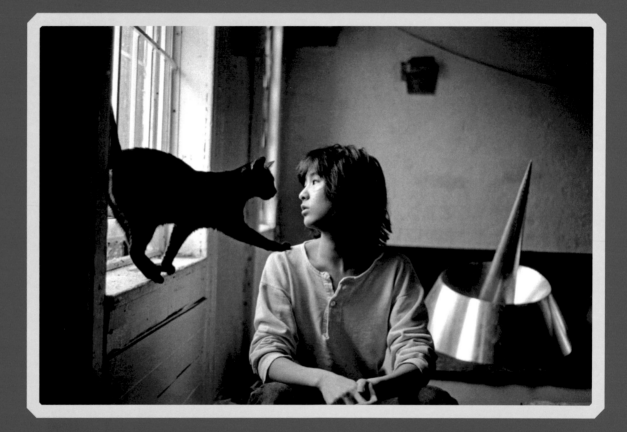

Maya Lin
New York City 1986

Table of Contents

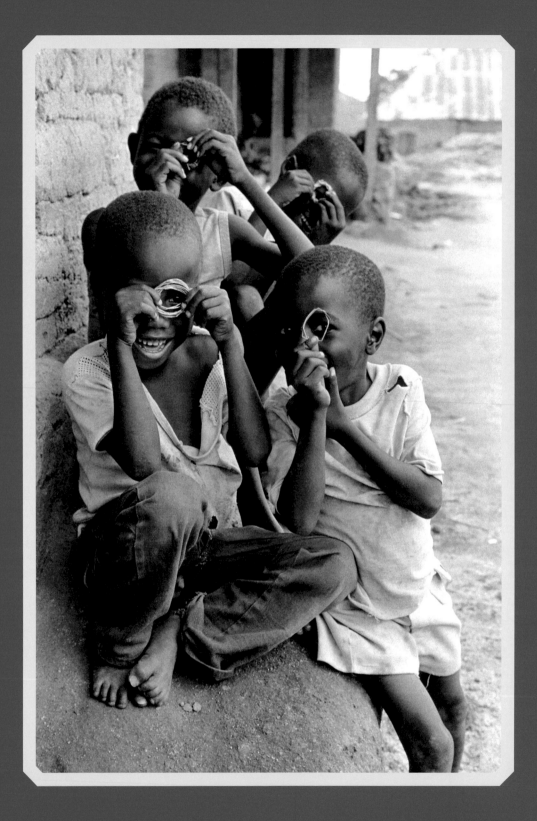

Foreword

In one of Michael Katakis' photographs taken in Sierra Leone in the 1980s, a group of young boys smile back at the camera, fingers circled round their eyes in imitation of the photographer. They form a happy collaboration with the image-maker, involved and included in the process. And this is perhaps the essential characteristic of the words and pictures in this book, which charts the wanderings of Michael and Kris Hardin to many places over the past decades. At its core, this is not a voyeuristic documentary of the foreign or the strange, but a record charting an unfailing fascination with and faith in the characteristics of human society which bind rather than separate.

The photographs and journals entries in this volume—an intense partnership over many years between the photographer and traveller Michael Katakis and his anthropologist wife Kris—range over many continents, from North America to Africa to the Far East. But it would be mistaken to view these images and words as those of a traveller in search simply of exotic images. While undoubtedly captivated by new experiences and new countries and driven by limitless curiosity about the lives, experiences and beliefs of the people he encounters, these pictures speak most tellingly about the connections between peoples rather than the differences. Katakis has always been aware that the inexhaustible fascination of human variety is not limited or defined by geography. Everywhere we are both different and the same. America itself, the source in its power and influence of so much that is both inspiring, refreshing and terrifying in the world today, is equally subject to the photographer's curiosity—his documentation of relatives and friends of the dead who are remembered in the sober elegance of the Vietnam Veterans' Memorial forms an extended meditation on the unhealed scars

of that war. A similar need to understand the meaning and implications of modern terrorism drove him, in the aftermath of 9/11, to record the response of his own countrymen to this devastating event: the family group in the Breakfast Nook in Rapid City, South Dakota or the construction workers encountered in Sheridan, Wyoming form a compelling metaphor for the complex amalgam of incomprehension, confusion, anger and sadness which this tragedy unleashed among ordinary Americans.

A coda to this book is a lengthy letter written to President George W. Bush in December 2010, expressing the author's horror at his government's response to the destruction of the Twin Towers. One wonders whether such a letter was ever permitted to puncture the comfortable pneumatic layers which insulate high office. It is doubtful. But its commitment to expressing the values of a humanitarian engagement with the lives of ordinary people—whether in Sierra Leone, China or Washington DC—speaks of a continuing determination to speak out in the cause of both tolerance and honour and not to become a silent accessory to injustice.

Any balanced view of the world in the early 21st century must acknowledge the frightening tensions, ideological barriers and economic inequalities which separate and threaten to overwhelm us. While Michael Katakis does not shy away from this present bleakness, his work still defiantly illustrates a commitment not to surrender those values which might offer the only feasible route to a saner world—a recognition that despite the exhilarating and endless diversity of human societies, we also share common dreams and aspirations. These pictures and words are the authors' attempts to give concrete form to this manifesto.

John Falconer
Curator of Photographs
The British Library
London February 2011

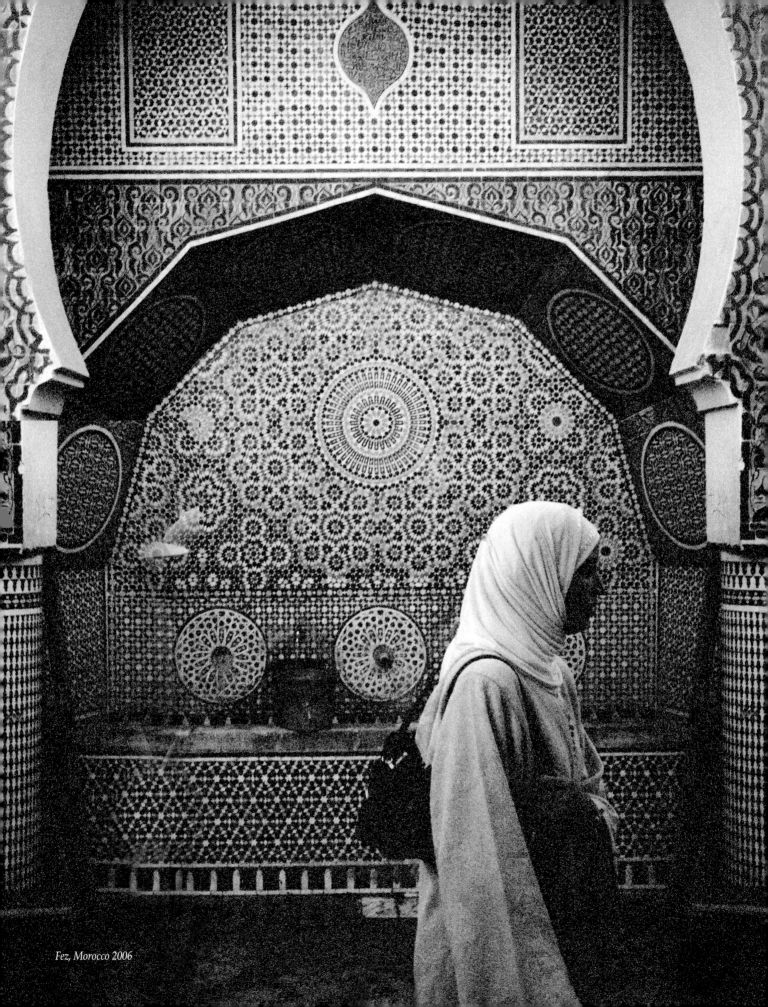

Fez, Morocco 2006

Introduction

Michael Katakis is an indefatigable traveller. Driven by a restless curiosity and a belief in the importance of the individual against the system he puts his humane and enquiring ear to the ground and picks up signals that are salutary, precise and stimulating.

His thoughtful words and pictures confer dignity and provoke indignation in equal measure. He guides our eye and our conscience through the world without ever having to resort to hustle or harangue. There is a peacefulness at the heart of his work which gives us time to think. Michael's work doesn't have to shout to be noticed. It engages us through its honesty. There is no barrier of style or defensive wall of artifice and he does not deal in obscurity or gimmickry. With Michael's work what you see is what you get and what you get is an overriding empathy with mankind, a concern for the way things are and a feeling that every aspect of human behaviour has value. In his writing, as in his photographs, he confronts his subject head on, so there is no mistaking the meaning of what he wants us to hear and what he wants us to see. This, in my view is what makes his work memorable, valuable and to use an over-used word, uplifting.

Allied to this precise and unequivocal delivery is a terrific appetite for people and places. Michael is the most un-parochial of travellers. His world-view is comprehensive. He has no favoured nations. His material is people, irrespective of where they live.

Though I have been friends with Michael for just over a decade, I wouldn't presume to know what makes him so insatiable and eager a traveller. His father was a Greek immigrant who fought in Crete during the war, and that might account for why Michael is frequently drawn back to Europe. For he and Kris, Paris has become almost a second home. Which brings me seamlessly to the greatest influence of his life, work and

travels. No, not Paris, but his soul mate and co-contributor to this book, Dr. Kris Hardin. The "strawberry blonde" in "a long black dress" described by Michael when they first met in a university lecture hall, has shared the last twenty-five years of his life. Michael calls her "my True North" and spending time with the two of them is to be aware of a shared sense of direction, with Kris, the anthropologist, tighter in her focus, but both committed to understanding the world better by better understanding its people.

Kris, like Michael, has a direct, uncomplicated ability to connect with those she meets along the way. Like Michael, she wants to know the stories of strangers and like him she writes in good, clear prose of which you will find many examples in this book. It was she who introduced Michael to Sierra Leone in West Africa where she had spent two years living with the Kono people in a small town called Kainkordu. The resulting images, particularly of the children with whom Michael and Kris made such friends, were first gathered together under the title *A Time And Place Before War*. They are not only fine photographs but were given an added, unintended significance by the awful events that followed shortly afterwards. The Sierra Leone civil war of the 90's was bitter and brutal and many of these endearing children never lived to adulthood. Despite the trauma of what happened to those who knew her so well that some named their children after her, Kris refuses to accept anything as pre-determined by fate or destiny. "It did not have to be this way," she wrote in an angry, admirably un-sentimental introduction to an exhibition of Michael's photographs at the Royal Geographical Society in London in 2001.

Michael is attuned to loss and in particular to loss of innocence. His reaction to America's war in Vietnam is not to be found in battlefield pictures but in his moving study of the Vietnam Veterans Memorial, a two-year project and his first collaboration with Kris Hardin. Those who died form the background to their study, but the emphasis of their observation of the Memorial is on those still alive. They chronicle the families and loved ones who have to live with their loss. Death is acknowledged but it is life, all human life, that is Michael and Kris's raw material.

Michael's way of dealing with the events of 9/11 was not to rush to the scene and capture the destruction, but to look instead at the wider impact of such unprecedented slaughter on those who had to live with it. Three days after the terrorists struck, Michael set off across the country to gauge the mood of the people of America ; to see if the effect on the national psyche "could be as reflective as it was reactive". He found the

results unsettling. "If we as a country and a people wish to honour the dead, nothing will serve them or us as well as seeking the truth, not only about the terrorists..but about ourselves". Even on the day the Towers came down and emotions ran high, Michael's instinctive thoughts, as entrusted to his daily journal, and published here for the first time, are that, even under such pressure, honesty and humanity could not be compromised. He recognised with a prescience that's almost painful to read now, the damage that might follow when America's anguish turned to anger.

Michael is a passionate man himself, and his own anger with the response of the American administration after 9/11 led to his leaving the country and moving, for a while, to Europe. His disillusion is well covered and cogently explained in the book, but speaking personally I have to say that America's loss was our gain. Not only did we see more of Michael and Kris during their self-imposed exile, but I also got to share Michael's enthusiastic discoveries, often in hand-written letters scribbled on trains or at restaurant tables, of new cities, new dishes, a new whisky and new people he'd bumped into.

Which brings me on to the last thing I'd like to say about Michael. He is very good company. He feels things deeply and takes life seriously, but besides politics and war, this includes cooking and eating, discovering wines he'd never tried before or musicians and writers he'd never heard before. To be with him is to be with someone who makes you aware that for all the mistakes we make and for all the injustices out there, the world is, for those with eyes to see, a place of good people and many small, intense delights and pleasures.

The love and respect for humanity runs like a thread of gold through Michael's work. It entwines both him and Kris and all of us who believe that there is a way to tell the truth.

And it seems very suitable that the collected work of an American with a Greek father should be entrusted to a library in England, for Michael is, in the very best sense, a man of the world.

Michael Palin
London January 2011

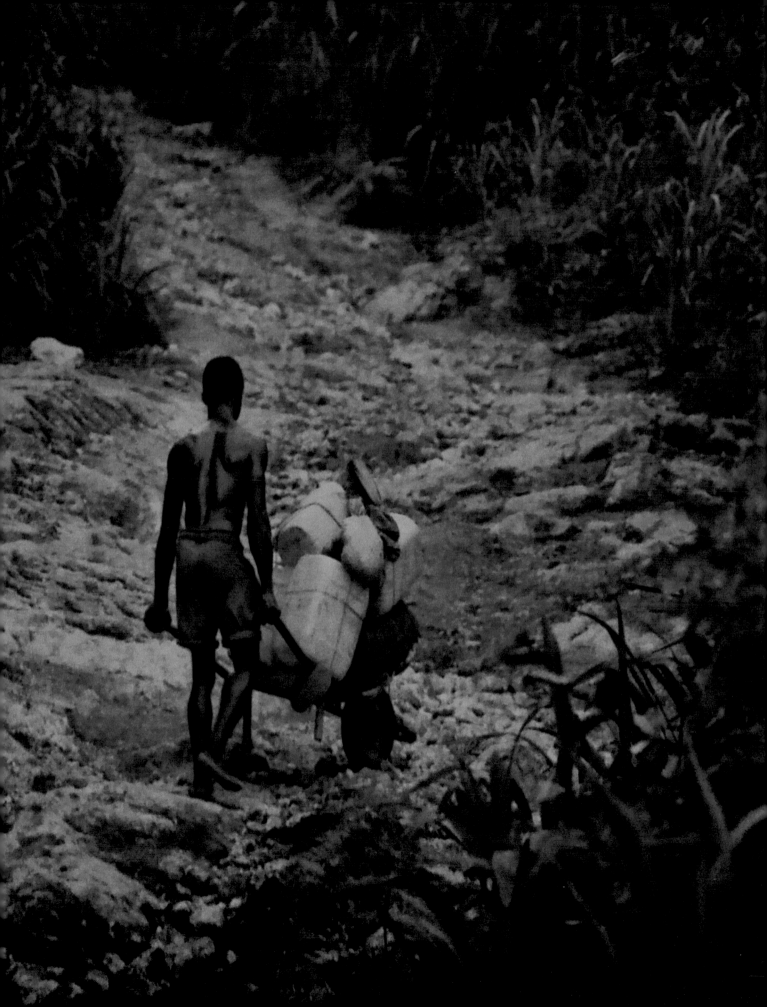

A Time and Place
Before War

Kris Hardin and her namesake Bondu Kris (Kainkordu 1988)

Introduction

London May 2001

Kris Hardin

In 1991 rebel forces marched into Sierra Leone from camps in Liberia. As they moved toward the diamond fields of Kono, more soldiers joined them. Thus began a nine year civil war in which kidnapping, rape, mutilation and other atrocities became commonplace. Over half the population of Sierra Leone was displaced at some time during the war. As we enter the new millennium, it is hard for most people to conceive of such violence and equally hard to imagine what will be left in its aftermath.

The Sierra Leone I knew was quite different. As an anthropologist I spent two years in the early 1980's recording the history and everyday lives of people in Kainkordu, a town in eastern Sierra Leone. They were ordinary people with hopes and dreams for themselves and their children, just like people everywhere.

To understand the civil war in Sierra Leone I find myself poring through old field notes at odd moments. Did I miss something? Is there some capacity for violence unique to the people I called neighbors and friends or Sierra Leoneans in general? I doubt it. Instead I have to ask why Sierra Leone? How could such violence happen there? What other factors were at work? Perhaps some of the answers can be found in the stories of the farmers, schoolteachers, traders, singers and others that you see here. I don't know for I am still trying to answer the questions myself.

Photographer Michael Katakis took these images when he accompanied me on a return trip to Sierra Leone in 1988. They are some of the last photographs taken of the area around Kainkordu and its people before the civil war began. Many of these people may be dead now and much of Kainkordu has been destroyed. Instead of romanticizing the time before the violence, the photographs record a time when people were unsure of what the future would bring, but no one could have foreseen the brutality that was to come.

The quality of life in rural Sierra Leone in the 1980's declined dramatically. My field notes show people's growing awareness of their isolation from education, health services, and the economic opportunities that were becoming commonplace in other parts of the world. By 1988 bad roads made it nearly impossible to market rice or other crops except for occasional illegal trade over the border into Guinea. Kainkordu still had no power or running water. Teachers complained they were rarely paid by the national government, books and writing materials in the schools were increasingly scarce. Students had little reason to try to advance through education because there were few jobs. By 1990 the United Nations Development Fund ranked Sierra Leone last in a list of 160 of the world's poorest countries. Even before the civil war began, life in rural areas like Kainkordu had deteriorated to the point where the only viable avenue to a higher standard of living for most had become illegal diamond mining.

Things have not gotten better. In the year 2000 the World Health Organization ranked Sierra Leone last in the world in overall health care.

It did not have to be this way. There were resources to pay for schools, health care, roads, and other basic needs. In the 1980's, even before the civil war broke

out, some researchers estimated that up to eighty percent of the diamonds mined in Sierra Leone were exported illegally. Benefits from this illegal trade never reached the people of Kainkordu. The civil war only continued this practice. Rebel groups were estimated to be making up to sixty million a year from illegal diamond mining. It is difficult to calculate how much of this was spent on weapons to keep the war going, but many around the world, including some connected to the arms and diamond industries, and some who served as middlemen, have benefited from the illegal trade in diamonds from Sierra Leone.

As the war comes to an end, many are hoping for a time of reckoning. The United Nations is currently organizing a Special Court to hear testimony about atrocities. At best we can hope that those responsible for the most brutal acts will be held accountable. Most of the guilty, whether inside or outside of

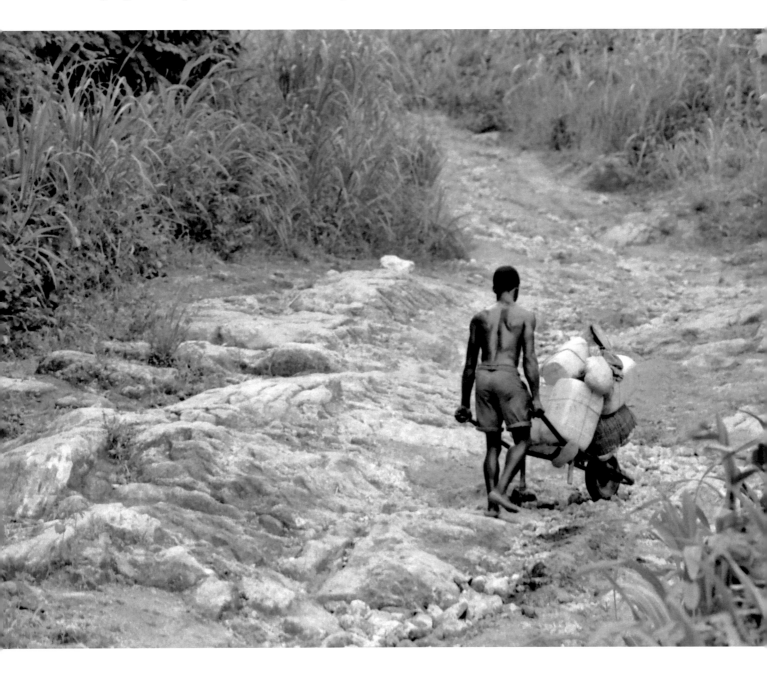

Sierra Leone, will never be marked as criminals. But after the trials and reconciliation hearings are over, these photographs will remain- ghostly reminders of the people I knew in Kainkordu and of the cost of putting profit ahead of human life.

Michael Katakis's photographs are a testament to a time before war. They show us how ordinary people's lives in small unknown places can be torn apart by the injustices that follow greed and commerce in commodities like diamonds and weapons on the world stage.

The photographs are also important because they counter some of our preconceptions about a vast and diverse continent. The word "Africa" must call to mind more than game parks or romanticized images of peoples in pristine and exotic places. Africa is also more than the images we have seen lately showing the catastrophic effects of war, hunger, and poverty. Michael Katakis and I have another view of a small part of Africa, one that records a moment of real life and the people who lived it.

Trader on route to Kainkordu, 1988

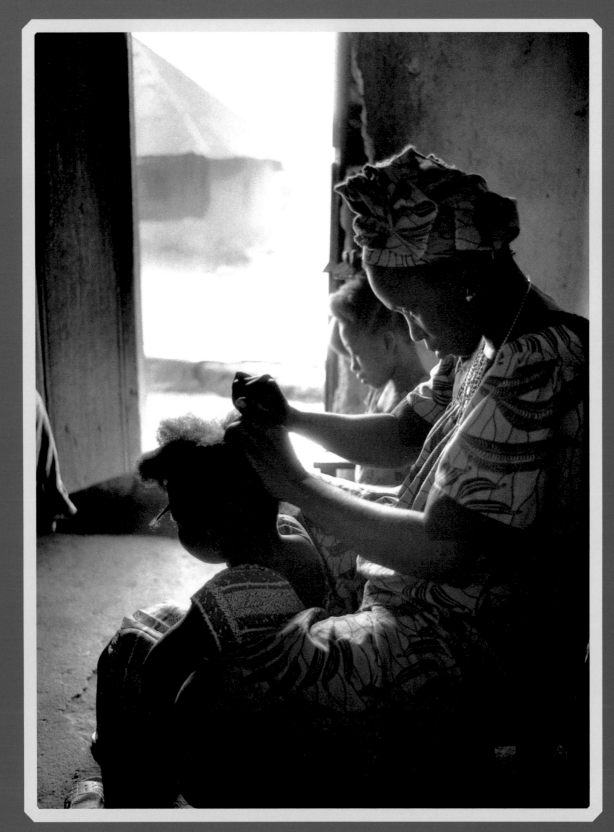

Woman plaiting daughter's hair (Kainkordu 1988)

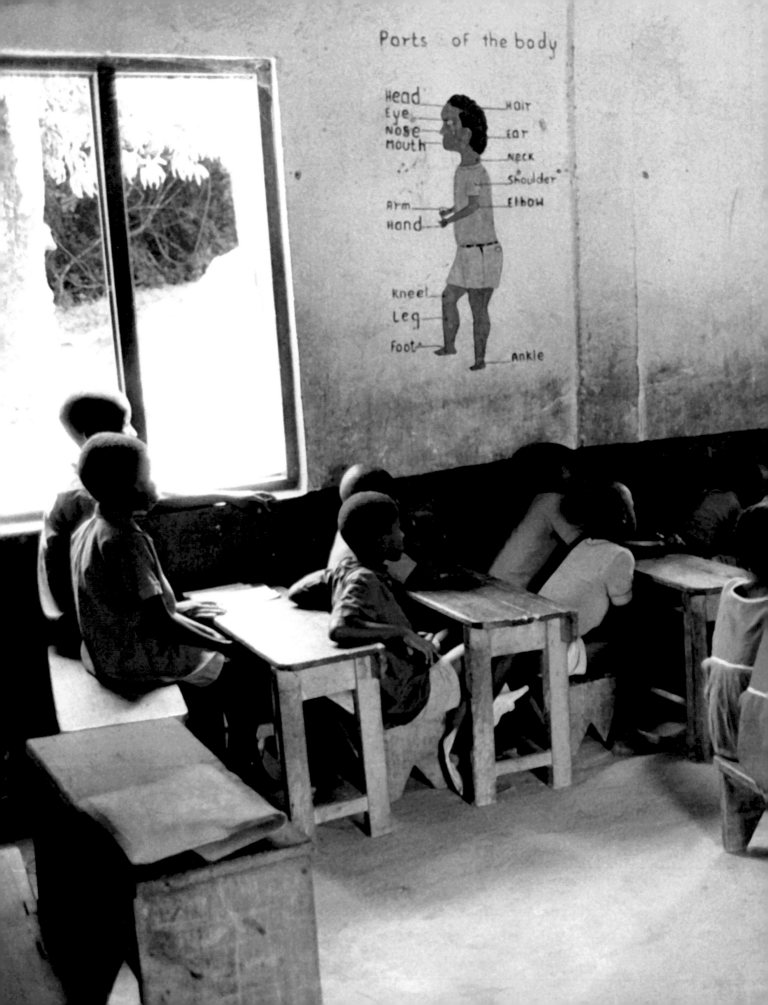

Classroom and students (Kainkordu 1988)

Corporal Tamba

Kris Hardin

I don't remember when I first met Corporal Tamba. I used to pass his house as I walked to the weekly market at Igbeda. He would have spotted me long before I had reached his house and would hide on the veranda and then suddenly pop up to say hello dressed as he always was in a brown tunic and woolen cap. Sometimes he even held his flintlock across his body.

He was one of the elderly men from Kainkordu who had done service with the British military during WWII and most had become hunters when they returned to Kainkordu.

Being a hunter meant knowing about the dangers of the forest and the creatures that lived there. It also meant having special powers to control those dangers. Some of this power came from abilities with firearms and the perceived courage of these unique people. I became aware of the hunters when some of them approached me asking me to buy ammunition for them in Freetown. At that time, in the 1980's, having and trading in ammunition was illegal so I refused. Since that time the hunters found their own ways to acquire money and ammunition.

Corporal Tamba had become a "Looking Groun' Man" which meant he told fortunes and predicted the future for anyone having questions or problems with their lives.

I saw many pregnant women approach his veranda and take out the coins they had carefully tied in their clothing. They gave the coins to Corporal Tamba and then were invited into his reception room to ask their questions. I was intrigued, and before I left Kainkordu, I decided to consult the Corporal. When I asked my questions, the answers he gave revealed the major concerns that people in Kainkordu had about this young, single, female graduate student. I would marry and there would be no concerns about money and I would marry happily and would finish the work that I had begun in Kainkordu. All those predictions seemed safe enough, but unfortunately that was not to be the end of the story.

About six weeks after the civil war began in Sierra Leone, I received an e-mail from someone in touch with Kainkordu and was told that the hunters in town, when it was announced that the rebels were coming into Kainkordu, formed a line across the road to defend the town. Corporal Tamba, then in his late 70's, was among them. The old men with flintlocks who had once been soldiers stood their ground and then were cut down by the rebels with their modern weapons. When I think of Corporal Tamba now, I think of the questions that I did not ask and the man with a kind smile who would surprise me on his veranda in his brown tunic and wool cap.

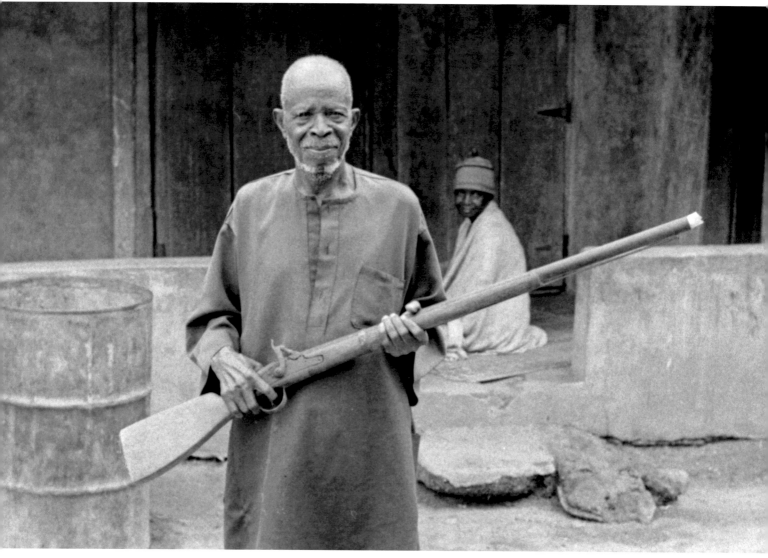

Corporal Tamba with his flintlock, Kainkordu 1988

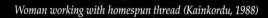

Woman working with homespun thread (Kainkordu, 1988)

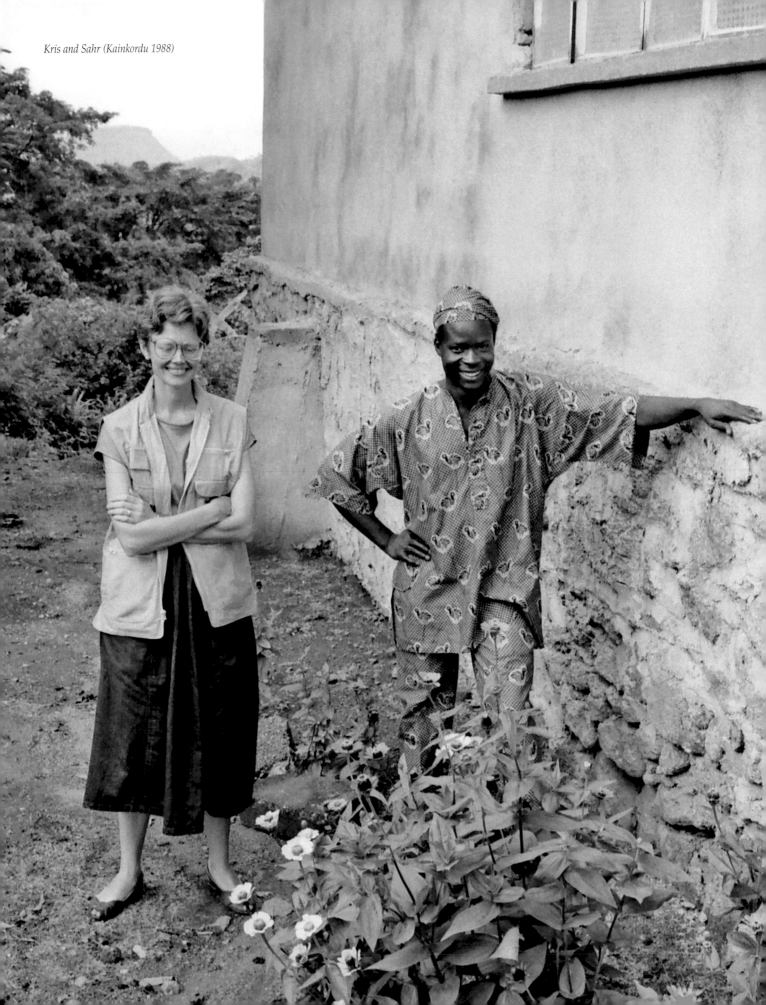

Kris and Sahr (Kainkordu 1988)

Satellite Boy*

Kris Hardin

When I first met him at the lorry park in Koidu, he seemed no different from many other young Sierra Leoneans who had approached me to try their English, to impress their friends, or just because there was nothing else to do on a hot, dusty day while waiting for transport. I guessed he was about sixteen or seventeen. He explained that he was Kono, that he had been in school, and that his mother was in Gbomandu .

Are you going to Gbomandu? he asked. "No," I said bluntly, hoping this would cut off the conversation. I was always polite, but to be more forthcoming with young strangers usually opened a floodgate of requests for food or money. There were no other trucks to Kainkordu that day, so, resigned to my fate, I sat down to wait. As minutes ticked by, the lorry park emptied out. A faded blue Isuzu left for Kayima with enormous baskets of dried fish and two live goats tied to the roof.

"Where are you going?" the tall, thin young man asked again in precise English. "Where exactly?" he persisted. "Kainkordu," I said and turned back to the woman next to me. After several minutes he walked away. An hour later we were still sitting in the blinding sun when he reappeared.

"Would you like me to escort you?" I had run into this tactic before. He would make sure I got a seat on the truck, load my bags for me, and generally shepherd me around. In return, I would pay his fare on the truck. "No, that isn't necessary. I have been there many times. I know the way."

"Oh," he said, disappointed. "I have to go to Gbomandu. My mother is there and will take care of me."

With that, the first layer of his story tumbled out. He had been a successful student in a Koidu secondary school, but he had dropped out. This was a familiar story. I had puzzled over why students from poor farming families tried so hard against such odds to get through school. Over time it became clear that farming, the only occupation open to people who stay in the countryside, is seen by most young people as a sign of backwardness, a lack of progress. To add to the problem, the stigma against farming kept young people from returning to the land, even though farming, in most years, provided more security than the search for wage employment. Hopelessness was never far away.

The young man continued, "You know, something just happened in my head that stopped my schooling. I don't really know what." This was not unusual as I had heard of sudden illnesses stopping a young, successful student's education. One woman told me that she developed headaches when she tried to study. Another began having trouble focusing her eyes. Dreams are important to the Kono, so, it was not unusual for a young man's dreams to provide guidance.

Slowly, however, I began to see that the young man standing in front of me in the lorry park had a more complicated story. It was true that his family had been on the edge financially and that he had gotten sick, but there was more. His neat, well-kept clothes, the slow precise speech, and the fact that he seemed to be alone, all made him stand out.

It was not until two months later when I saw the tall, thin young man at the market in Manjama that

I found out how much more complicated his story was. By the time I walked into Manjama, the fish traders had claimed their usual place on the western side of the dusty roadway where the market spread out. I remember I was sitting at the government produce buying office talking with the buying agent about farming and smuggling. Suddenly, the tall, thin young man appeared. He smiled widely and his hand shot out in greeting. I groaned silently. The last thing I wanted was to be followed around the market by someone who wanted to "help" me bargain or serve as my guide. We invited him to sit down and join our conversation, but things took a bizarre turn as the tall, thin young man inserted a litany of non sequiturs: my mother is not here; there is no one to take care of me, you know, usually she will take care of me; I don't know what I am going to do; I have no food, it is just too lonely to be here. Finally, the young man told me he had decided to go to his father's the next day, a few miles behind Jagbwema, and that he would stop to see me as he passed. I groaned silently.

By the next day I had forgotten the encounter, but at mid-morning I looked up to see the tall, thin young man walking toward the house. He was carrying a plastic nylon bag and a small white case. At first I thought it was a briefcase, but as he got closer, I realized it was a jewelry case, the kind of white faux leather box that I remember seeing on my mother's dresser in the 1960's. Someone had simply added a knotted twine handle and a makeshift latch and the transformation was complete.

We parlayed the standard Kono greetings back and forth and I introduced him to my husband, Michael, and a guest who had spent the night with us. "Mr. Michael," he said to my husband, "I want to go to my father. My mother is not in Gbomandu. I do not know where she has gone. It is just too lonely there and I am not feeling well. My heart is just fluttering and beating irregularly. I don't know what I should do I have no food or medicine, but I have papers. Would you like to see them?"

Without waiting for an answer, he went to his briefcase, opened it, took out a stack of yellowed, dog-eared papers and asked again, "Would you like to see them?" Again, without waiting for an answer, he pushed them into Michael's hands. "It's about the satellite," he said in a matter-of-fact voice. Michael's eyes got big. I quickly looked at our guest, and for a brief instant, thought I had become part of an episode of the "Twilight Zone." There was no way for Michael to avoid sifting through the papers. I moved behind him, and over his shoulder, saw pages and pages of description in legible, grammatical script.

"The satelite (sic) moves through the clouds collecting information about the weather and the earth...."

Michael turned the page and I glimpsed more entries. They were neat and precise. Those I saw were dated. Some had drawings that looked like star patterns with dots. I asked about these and he explained that they showed the course of the satellites that he had seen.

"How long have you been doing this?" I asked. "Oh, a long time now. I can't remember when I started." He shuffled through the papers, searching. "The first entry is not dated. I cannot sleep. It is just something to

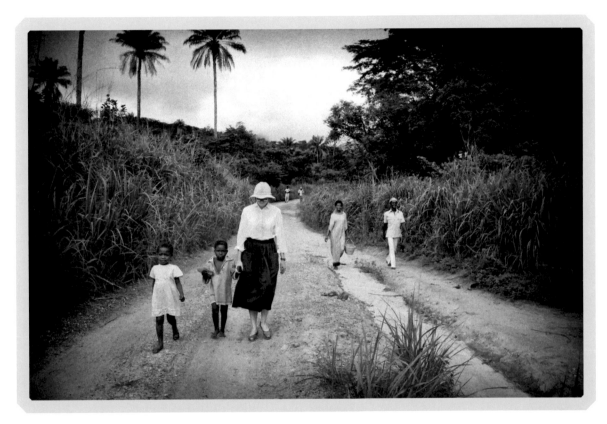

Kris Hardin with children returning from Manjama, 1988

Market woman selling pineapples (Kainkordu 1988)

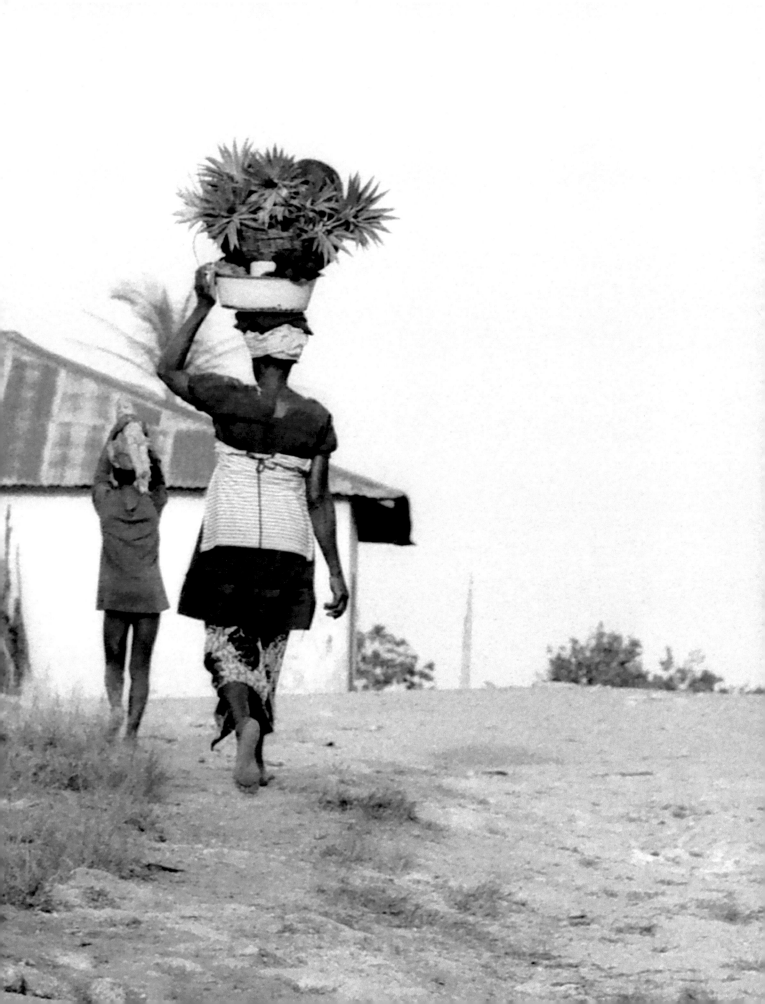

keep me busy. I watch the sky at night."

Michael handed me the stack of papers and went inside to collect himself. In the silence the tall, thin young man started speaking. "I just want to ask one question. I have been looking for someone who can answer one question for me. Do you know anything about satellites?" His gaze had settled on my friend, an art historian by training who replied, "That's really not my field. I wish I could help you."

By that time Michael had come back outside. "Do you know anything about Apollo?" the tall, thin, young man asked him. "A little," Michael answered. "Did it start with Apollo 1 and go up to 11 or 12?" Again, Michael replied, "I really don't know. I suppose it started with Apollo 1, but I don't know how many there were." The disappointment on the young man's face was painful to look at.

He tried again. "Do you know what it looked like?" Michael answered that he didn't know for sure, but thought it must have been shaped like a cone. The tall, thin young man let out a long sigh, then collected his papers and put them back into his briefcase. He

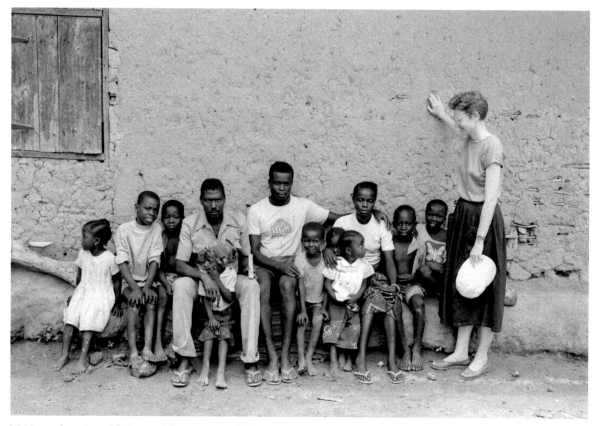

Waiting on the main road for transport that never came. 1988

cleared his throat with an air of finality and looked up the road, squinting against the light.

"Well," he finally said, "I am going to my father's. Even though I am not feeling all right, perhaps he will give me food." "Wait!" I replied and ran inside to grab whatever I had in the pocket of my sweater. "Buy some food for the journey," I said, shoving small bills into his hand. He barely looked me in the eye and only mumbled something that sounded like thank you. Money had not been his goal. Disappointed, but finally convinced that the foreigners failed to share his world, the tall, thin young man collected his briefcase and plastic bag of belongings and wandered off the veranda into the hot mid-day sun toward the main road.

I still don't know if this was a kind of madness. I am certain his family thought it was, but this was not the madness I had seen in others in Sierra Leone—people shunned by their families, unable to call anywhere home, wandering alone from place to place begging, clothing and hair disheveled. This was different, the madness of those so certain of themselves that they wander for a purpose—to find a place where the world they have imagined and pieced together from bits and pieces of information from disparate and seemingly contradictory universes, exists for others, too.

That was the last time I saw him. I doubt if he reached his father"s that day and I don't know if he bought food with the money I gave him. Even after all the time that has passed, it is difficult not to think of that tall, thin young man when I look up at the night sky. If he is still alive, he is probably looking up, too, watching from some remote Kono village. Perhaps he sees the same satellites and stars I see. I wonder if he is still writing and recording trying to bring order to his lonely, imaginary world.

In Krio, the lingua franca spoken in Sierra Leone in the late 1980's, "boy" was used to refer to adolescent males as well as young men in their 20's and even into their 30's. Only as men marry and take on more status in their community do they grow out of the stage of boy. I use the term here because this is what the individual described here would be called by Sierra Leoneans.

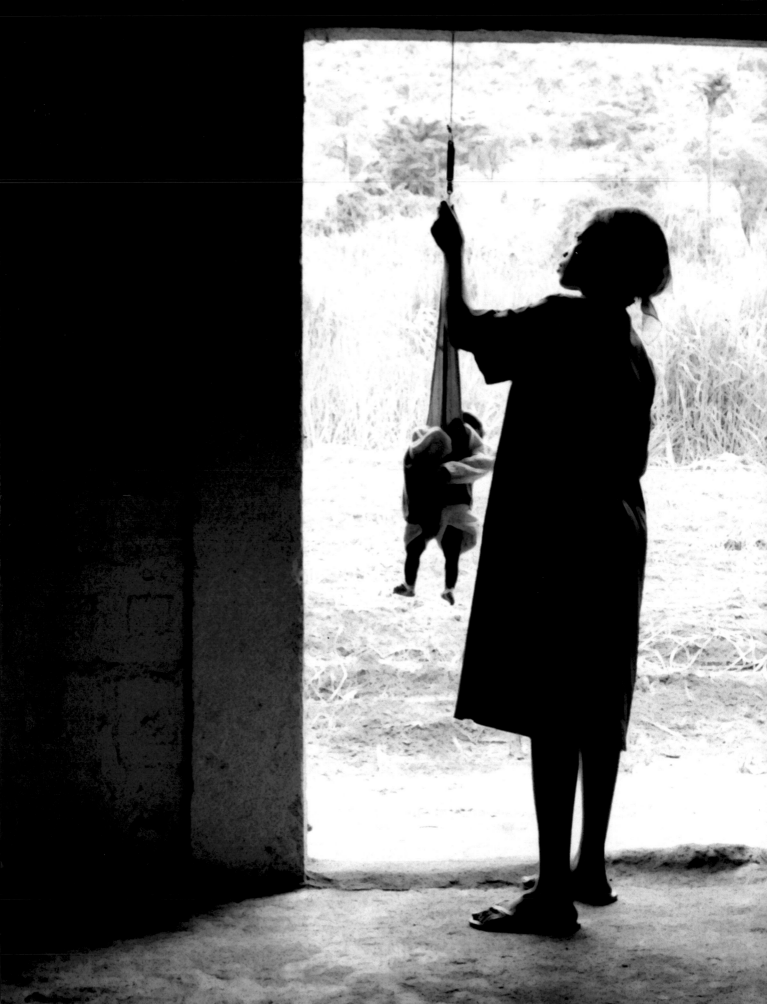

Agnes Sebba weighing infant at Manjama Clinic, 1988

The Importance of a Lie

Journal entry
18 July 1988
Sierra Leone, West Africa: Kainkordu

Sahr woke me early to say that someone had come. Half asleep I walked into the outdoor room to find a fresh pail of river water. I always take time for the morning bucket bath, sometimes luxuriating for too long because it allows me the only time to be alone. This morning I was annoyed at having to rush. Someone from Kainkordu needed or wanted something I thought or just wished to sit silent on the veranda, sometimes for hours, visiting in that strange Kono way to which I can never grow accustomed.

On the veranda sat a small, nicely dressed man in his twenties, I'd guessed. He rose to greet me with an extended hand and held a large box in the other. He seemed familiar and at first did not speak. I apologized for not having tea but offered him some filtered water which he took and drank quickly. I offered more, which he accepted.

"Do we know each other," I asked.

"No, but I…." His eyes looked behind me as Kris came out and joined us. He rose again and I was about to repeat my question when Kris said, "We met in the lorry park in Koidu did we not?"

"Yes, that is right. We met when you were trying to get transport upcountry to Kainkordu."

"You have traveled quite a way," I said. "Is there something we can do for you?" He became nervous and agitated, and, after what seemed a long time, Kris began to excuse herself when he quickly and, somewhat desperately, interrupted, "I have come to ask you questions."

With that he set the large box on the table opening it carefully so as not to further stress the already broken spine.

The contents, which he began to, and there is no other word for it, tenderly remove, were drawings and charts of the stars as well as old and yellowed newspaper clippings with stories about the American space program. There were stories about Mercury, Apollo and the names of some astronauts including John Glenn which were circled in red. The young man's hand drawings of Saturn and Mars were remarkable and on some of the pages there was a series of equations that I took to mean latitude and longitude but could not be sure. He went on turning page after page. In another place and time he would have been a student or perhaps a professor of astronomy I thought. His passion for the subject was startling and I could see that Kris, too, was amazed by the quality and sheer volume of his writings and drawings.

I told him that this was fantastic but my compliment was either ignored or not heard as he arranged more pages on the table. He then asked me his questions. They were about propulsion systems and temperatures on planets. Questions about Halley's comet and other astronauts' names and how the space program had developed after he had lost track. How far was the end of the galaxy and how long would it take to reach it and then questions about the theory of relativity. I was dumbfounded and could only manage a silly, insecure smile in response, and then, I made one of the greatest mistakes of my life. I told the truth. I said, "You have studied this so much and it's amazing but I'm afraid that you know much more about this than I do. I am learning from you and I can't answer your questions. I simply don't know."

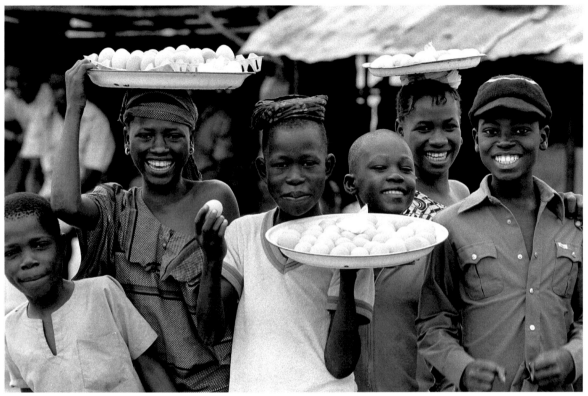

Egg sellers at lorry park (Koidu 1988)

The look on his face cut deep and in an instant I realized that he had not come for facts at all. He had come for new words to dream by.

Perhaps my words would have carried him until August or September and maybe well past. He might have lain in the tall grass at night staring at the stars remembering the veranda where we had talked and ponder what was said. Perhaps he would have fallen into deep sleeps and dreamt of stars and in those dreams he might have taken flight far from his life of questions with no answers and loneliness. But that was not to be for I made the terrible mistake of admitting my ignorance and removing myself from our delicate charade.

I learned in that moment, when I took everything from him, the importance of lying, not merely telling an untruth but lying, with passion and flourish like an actor on a stage claiming to know that which they do not know, for the lie that keeps hope and dreams intact is preferable to a truth that removes them. Lies and truths are easy to come by but dreams that sustain people through difficult lives are not. I wish I could take back the day. –MK

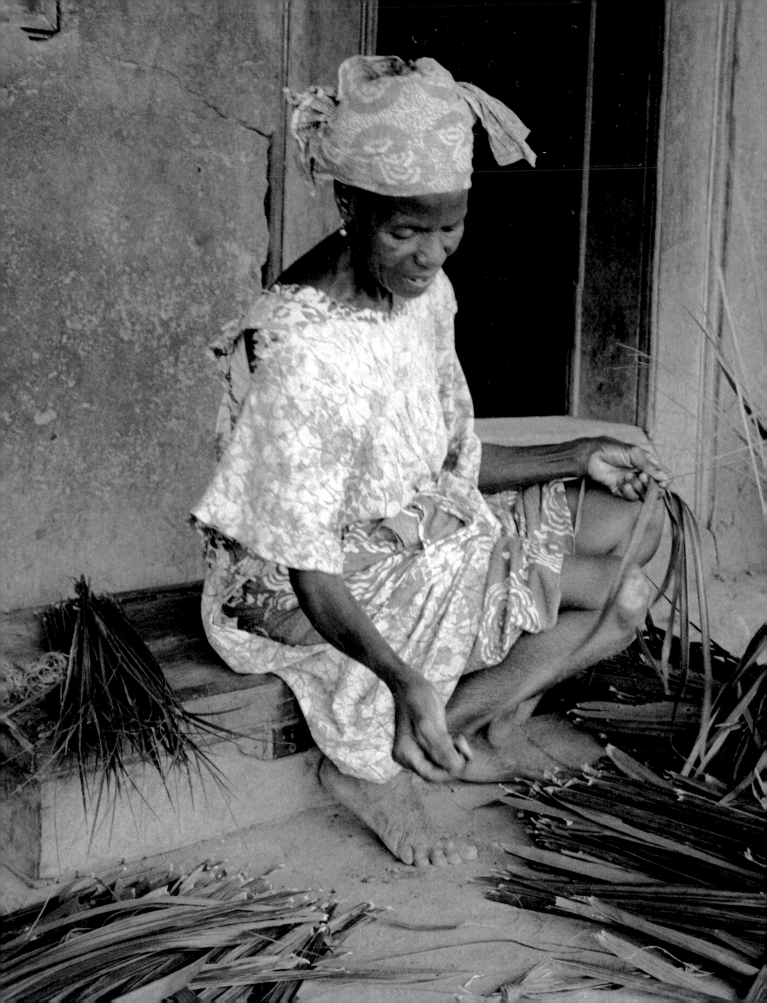

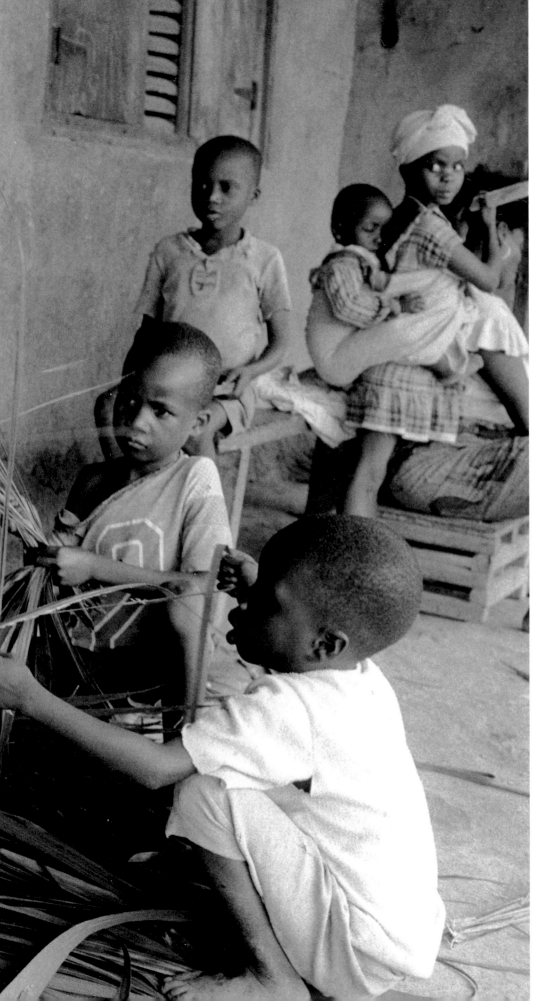

Family making raphia
(Kainkordu 1988)

The Little Girl I Could Not Save

Journal entry

3 August 1988

Sierra Leone, West Africa: Kainkordu

I know now as I watch her playing that she will haunt me for the rest of my life and remind me of my impotence and powerlessness and failure.

I have been watching my little neighbor for nearly a month now. She is a pretty little girl with an easy smile, pigtails and mischievous eyes. She is like little children everywhere with the exception that she is slowly dying of tuberculosis. The family has been told not to share utensils or bowls and to keep the other children from getting too close but it has not made a difference. Why would it, we are just outsiders. She is laughing this afternoon and somehow that has made me sadder because I want to extend her childish laughter into her teens and then young adulthood. I have talked with Kris a number of times about her and Kris has set me straight as to what I'm up against. I have money in my pocket that I am more than happy to just turn over but I have come to realize that money alone will not save the little girl with pigtails and sparkling eyes who is at present making faces at me and then smiles. Her teeth are so white. Someone with teeth so white can't be sick.

The treatment for tuberculosis here would take about six months. How the hell hard could that be? But I find that the little girl will have to travel a day's journey away and stay in the town for the duration of treatment. The family would need to have a connection with another family member in that place who would put her up and feed her and make sure that she got the treatments. The family would have to help pay for that. No problem, I could cover that. Then I am asked to whom I would give the money. I say the family. Then I am asked what I think the fam-

ily will do with the money. They will help the girl I answer. The answer is they will not. The family must stay and tend to their crops or all of the family will find themselves short of rice and that could start to endanger them all. Furthermore, it is discovered that the family has no relations in the places where treatment is available. I'm asked about transport and I realize I have been here for a month and have seen only two vehicles pass. Finally, I realize that the parents would take the money and use it for all of their children but not for one child alone.

It is now clear that the only way I can do this is if I stay for six months or longer and do it myself. I'm not allowed to stay in the country that long and even if I could, would I? Would the parents let me take the girl for treatment? Kris talks to them and the family discusses this among themselves. They came back and said that they would give us the girl.

That was the only solution they saw. She would then be Kris' and my responsibility. I could see that the mother was very pained about her little girl but she and her husband were not prepared to take money under false pretenses. They may have been poor but they were not without honor. The reality slowly dawned on me as I tried to understand their lives. They understood that things changed so quickly in West Africa that an emergency could descend upon them and they would be forced to use whatever assets were available even if it was money intended to save their little daughter. I looked at the mother as she cupped my hand. She was comforting me in silence while I tried to digest what was and what was to be. I suspect she had been through it many times

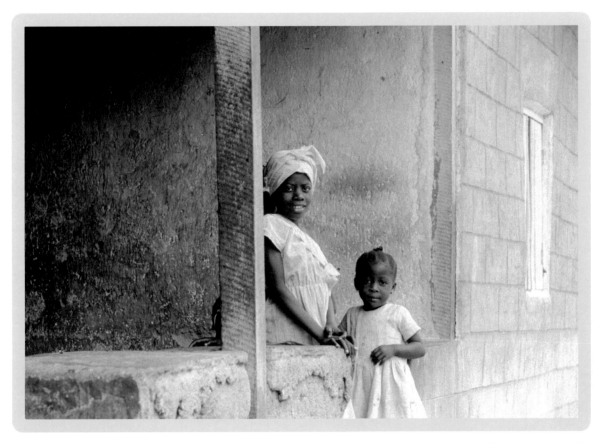

Kris and Michael's neighbors in Kainkordu, 1988

before, which made it no easier.

Knowing all of this makes little difference to how I feel. The reality is that I am powerless and a bit afraid. Afraid of a responsibility that I cannot take on and the realization that she is a picture in my head that will never leave me.

The little girl laughs as her mother holds my hand. She grabs my pants leg and tugs on it trying to get my attention. I look down and she points her finger up at me and laughs like little children do. –MK

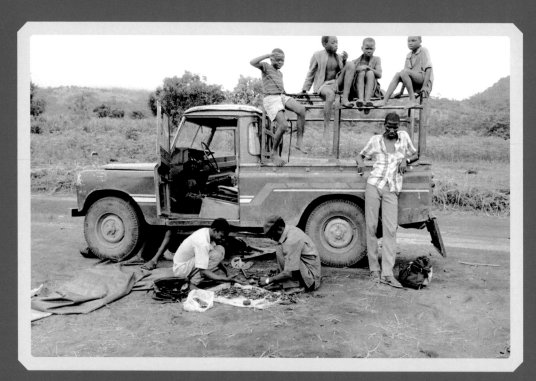

Breakdown in the middle of nowhere, 1988

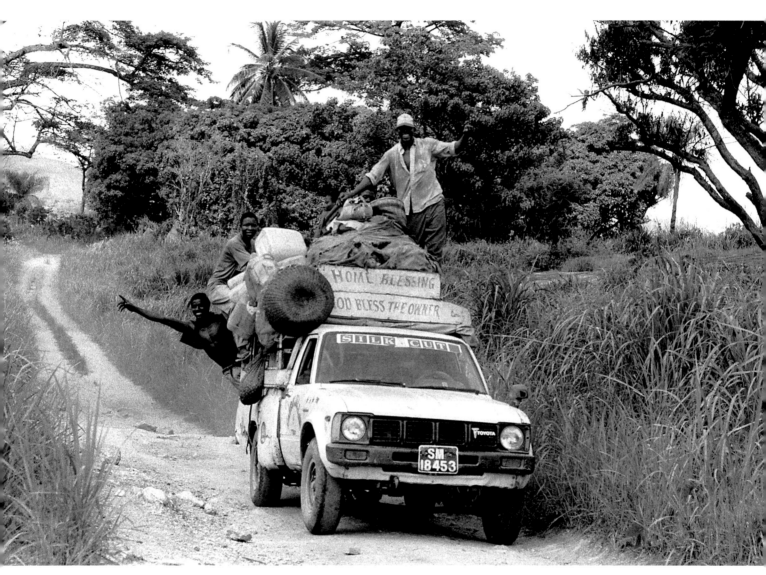

Drivers' helpers waving to the photographer as they pass, 1988

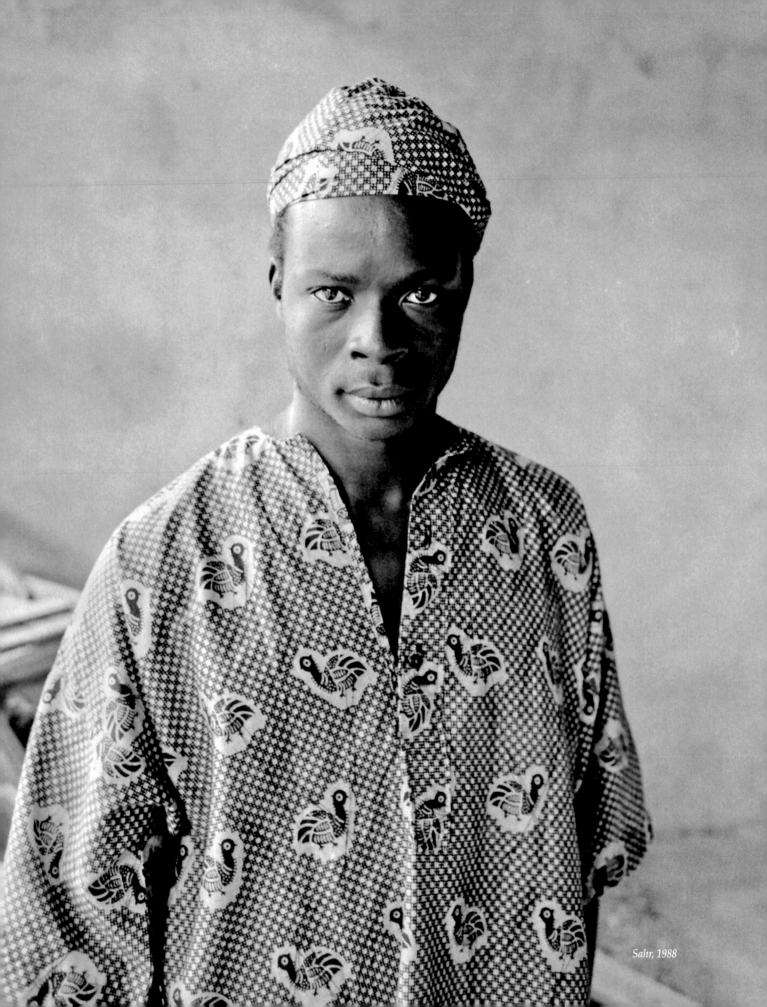

Sahr, 1988

The Invisible Man and the Man on the Moon

Journal entry

27 August 1988

Kainkordu, Sierra Leone

What a remarkable day. Sahr and I are walking to Mangema past the large tree. It is already very hot. Sahr is a fine man and very good company and has one of those sparkling minds that take in the world. We talk about many things and I am surprised when he tells me about his great grandfather who fought the British with his 'invisible cloak'.

"This is why the British could not find him," Sahr tells me. "He would enter a room with the British in pursuit and then cover himself with the cloak and disappear."

"Sahr, that's ridiculous. You know that's impossible," I say.

Sahr looks at me with determination and a bit of exasperation and retells his story with more flourish and even more remarkable hand gestures. We walked on and I do not recall how it came up but I told Sahr that the United States had landed men on the moon. With that Sahr begins to laugh so hard that he falls into the tall grass on the side of the road. Annoyed, I raise my voice over his laughter and say, "But it's true, they did land on the moon."

Sahr's laughter grows so loud and infectious that soon we're both laughing uncontrollably. Women walking the rough road barefoot with large bundles balanced on their heads pause and stare at the sight of us laughing and start to laugh themselves.

There we were, both on the ground, certain the other crazy and each of us knowing what we had said was 'true'. Never has an education in culture been more enjoyable. –MK

Travelers en route to Manjama market, 1988

....Sometimes, I dream of Sahr. He is walking ahead of me quickly. From time to time he turns, smiles and motions me to catch up. In front of him, is the giant spreading tree we often passed together. I try to keep up but am always behind. Finally, I am standing alone. I can no longer look at diamonds without seeing blood on them.

Journal entry
20 August 2000
Paris

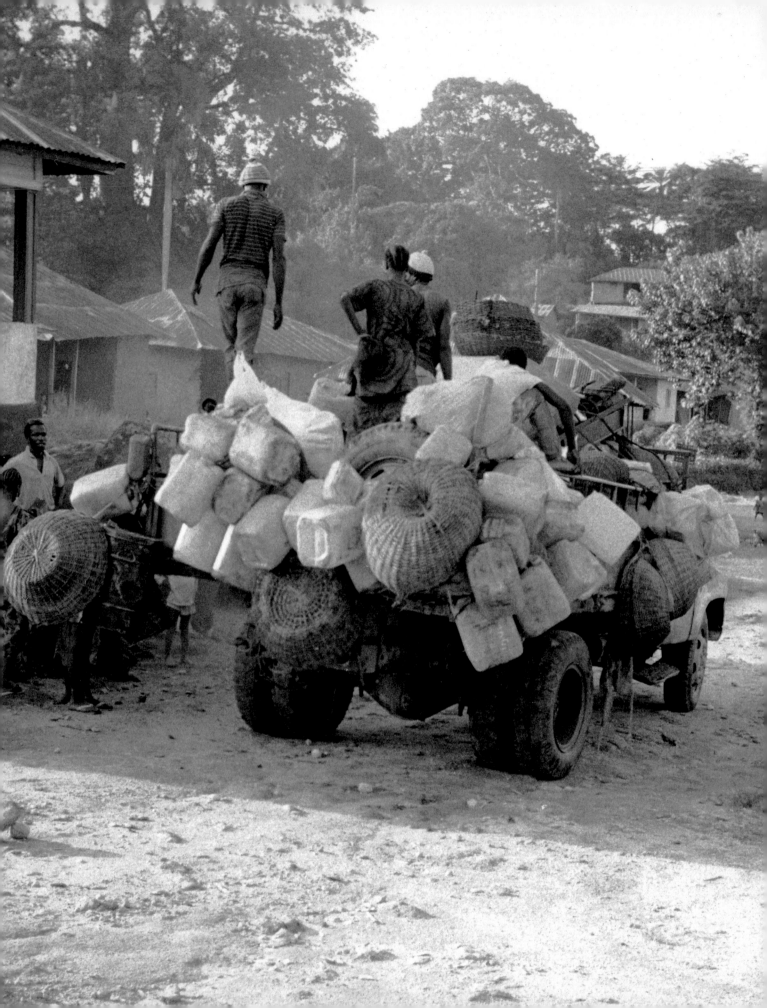

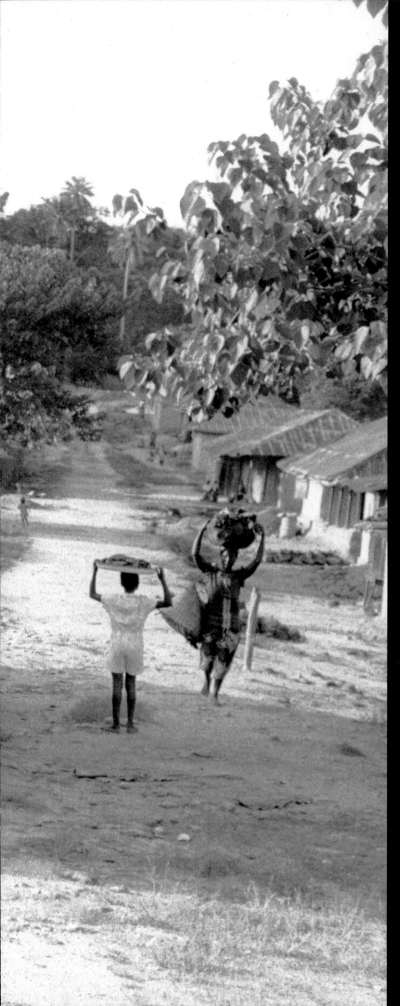

Truck loaded with goods heading for the Guinea border, 1988

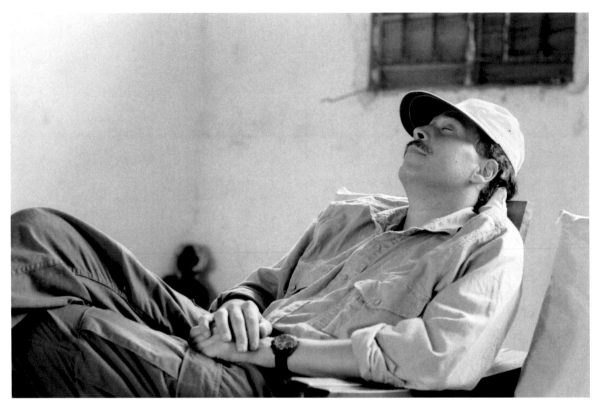

Michael Katakis sleeping after hours of helping to deliver a baby (Manjama 1988)
Photo by Kris L. Hardin

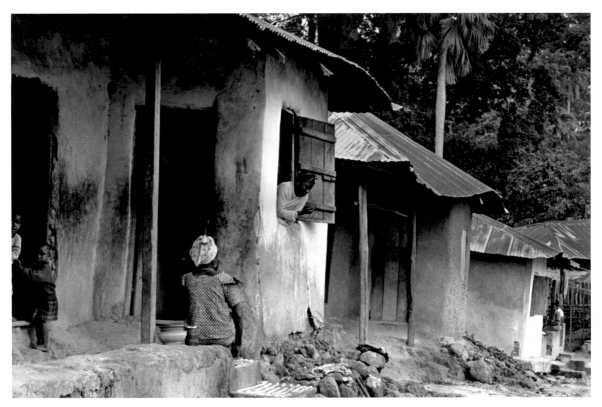

Kainkordu houses, 1988

Rice farmer on the way to his fields, 1988

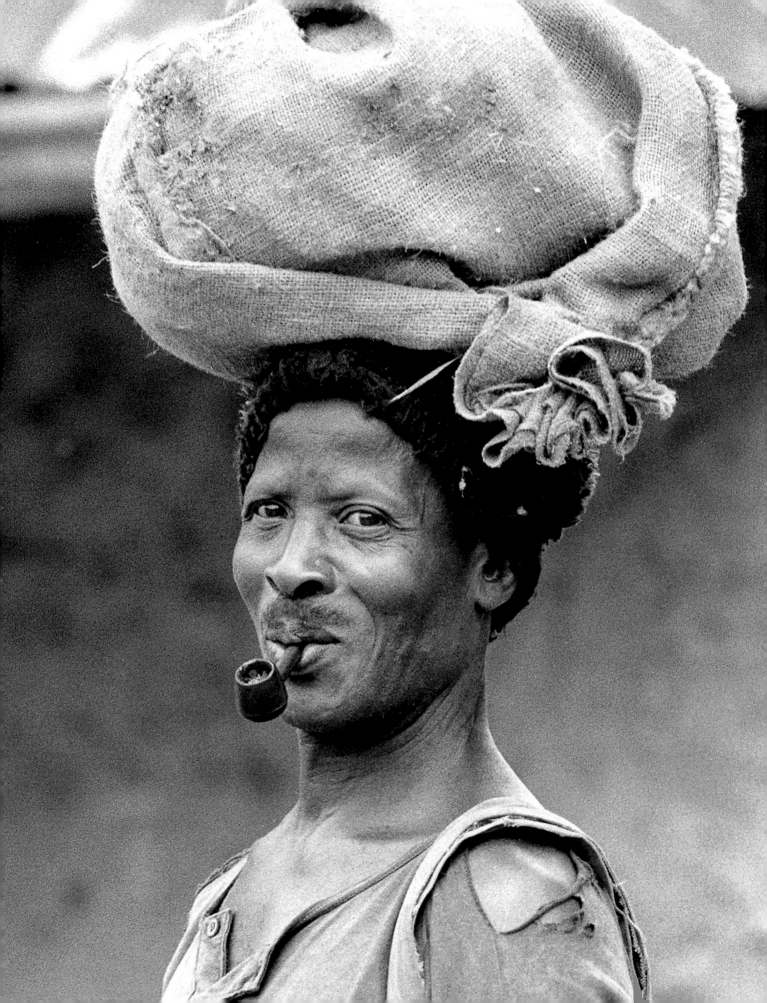

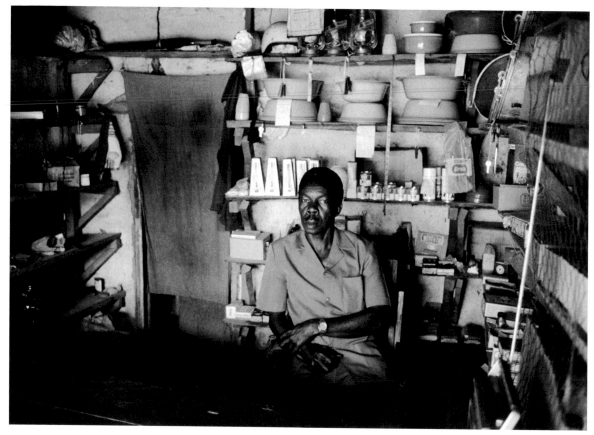

Kono trader in his shop in Manjama, 1988

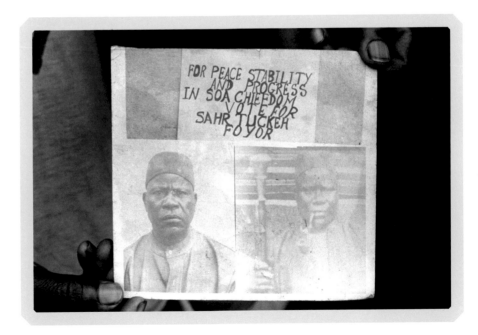

Campaign poster (Kainkordu 1988)

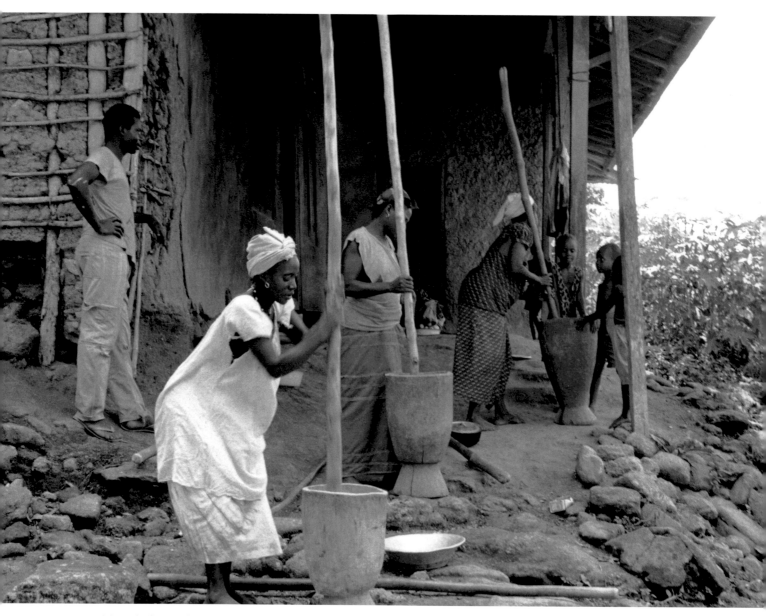

Women husking rice (Kainkordu 1988)

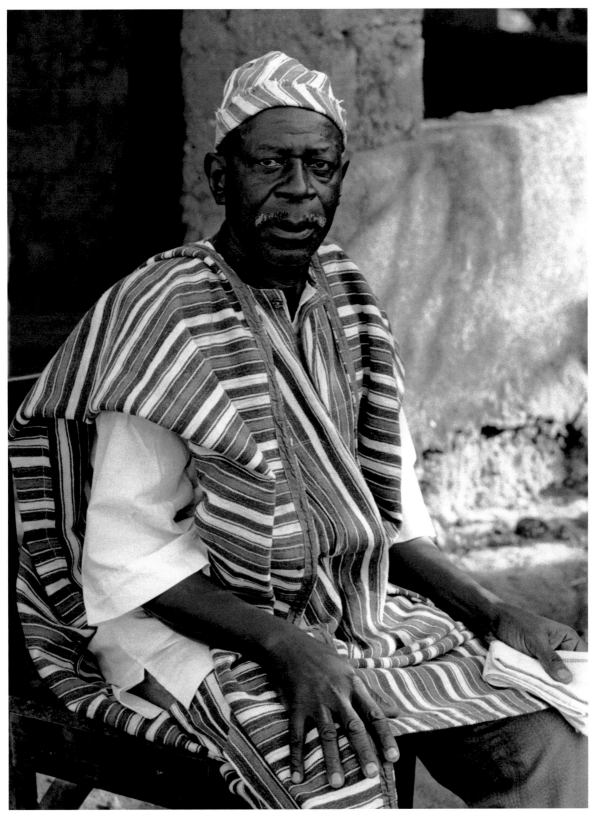

Section Chief Faiduo in his country cloth (Kainkordu 1988)

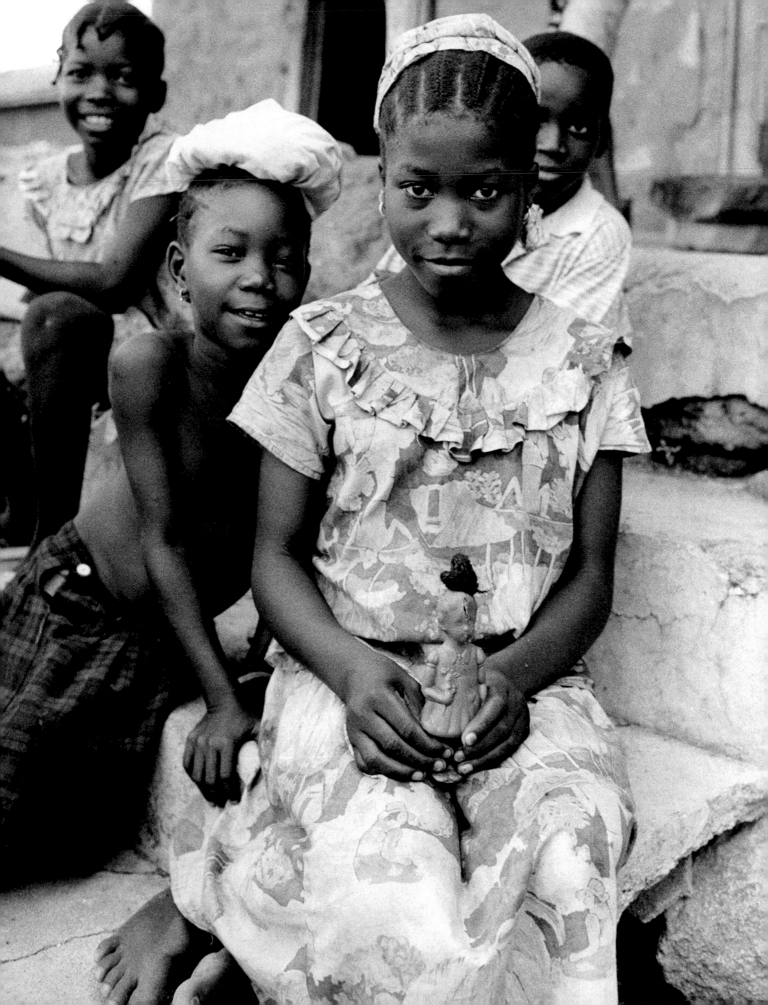

Kono girl with friends and doll (Kainkordu 1988)

A Sad Family Album

Journal entry
20 August 2000
Paris
(Written while preparing for the exhibition 'A Time and Place Before War' which opened in London at the Royal Geographical Society.)

One of my fondest memories of Kainkordu is waking on a bright Sunday morning and finding my friend and protector Sahr washing his three goats with an expression not unlike that of a California kid washing his new used convertible. There are many memories of that place and time that I have wanted to keep safe, but that is no longer possible.

As I look at these photographs now, they have become for me a sad family album with stories of murder, rape, and the mutilation of children and at the heart of it, diamonds.

I know in all probability that my friend Sahr was killed, along with many others in these photographs, and that Kainkordu may no longer exist. I no longer believe in countries, corporations, nationalism or unbridled capitalism. What I believe in is the right of the people in these photographs to have lived their lives full measure, with hope that one day life could be better for themselves and their children.... –MK

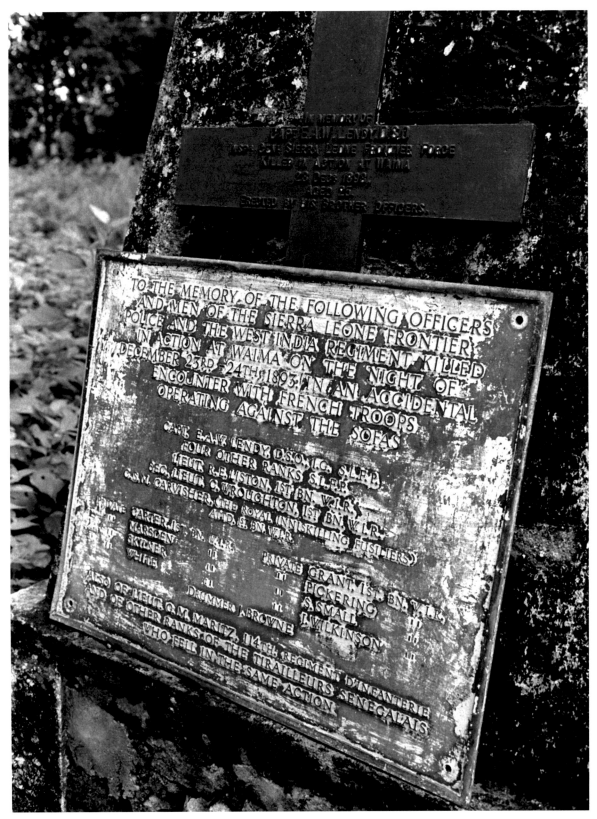

Monument at Waima for fallen British and French troops in 1893, 1988

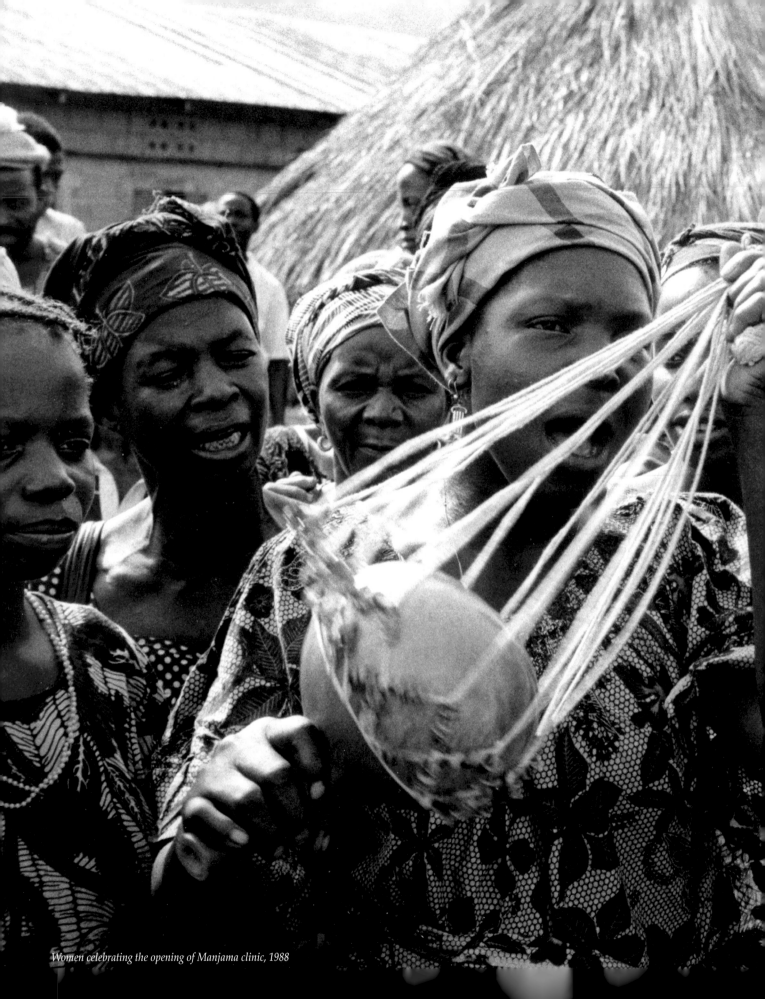

Women celebrating the opening of Manjama clinic, 1988

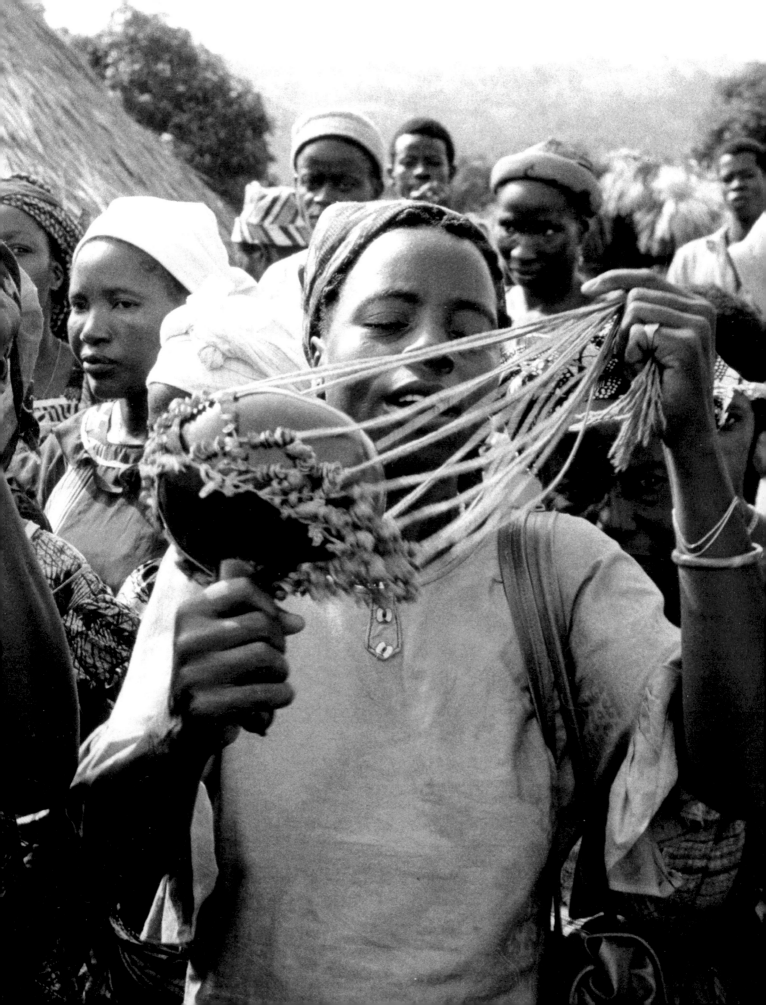

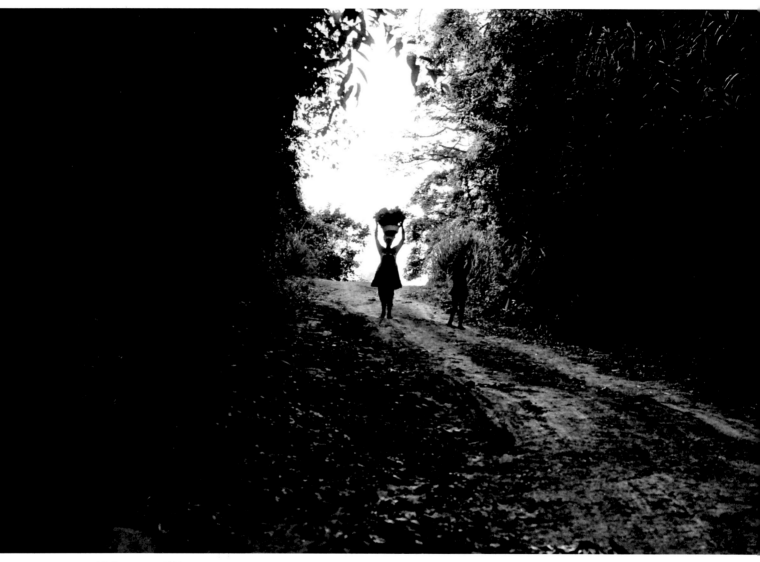

Market woman, 1988

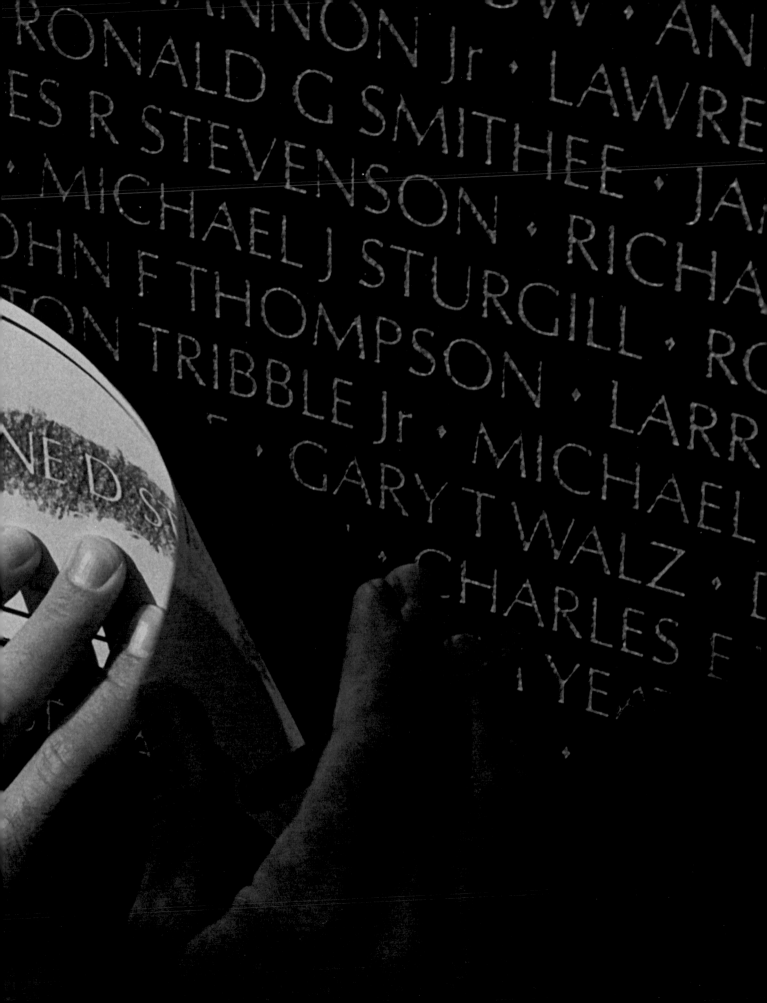

Vietnam Veterans Memorial

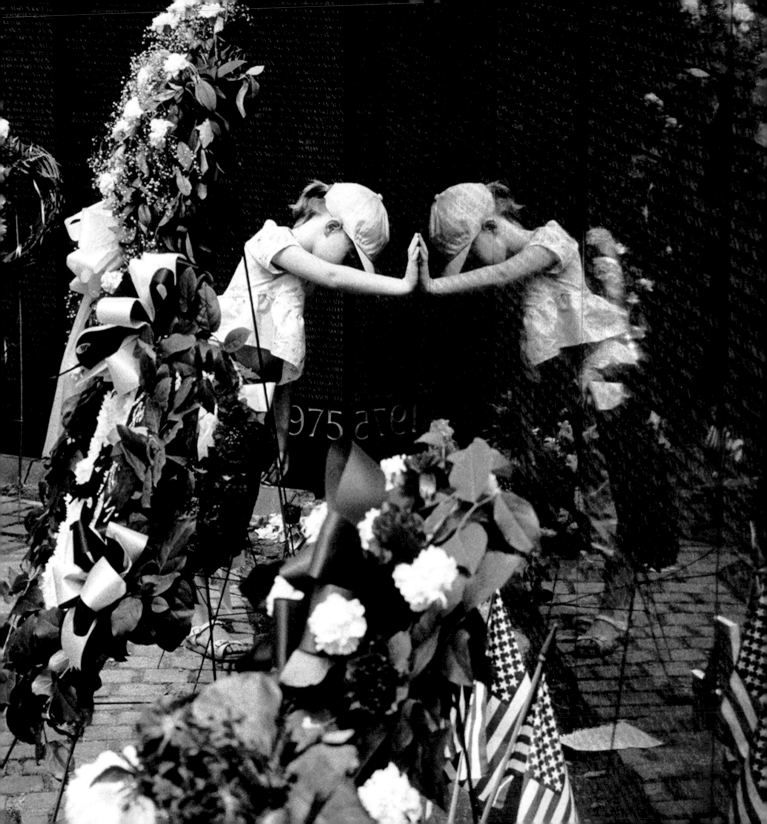

Ghosts In the Wall

Kris L. Hardin
1987

I am one of the lucky ones. I have no names to look up in the books that line the walkways as you enter the Vietnam Veterans Memorial. Instead, I have fading memories of an era.

Many of the veterans with whom photographer Michael Katakis spoke at the Vietnam Veterans' Memorial had similar experiences. They had feelings of having gone through something that had altered their lives or changed the kind of people they were. They speak of not being able to describe, examine, or understand those changes, and of having found few people around them willing to listen.

While those of us who stayed home may have been painfully aware of the moral decisions all servicemen are forced to make, our government and we as its citizens were unwilling to accept responsibility for those decisions. As a result, we found ourselves faced with unanswered questions. Could there be heroes in a war that was still going on and that we seemed to be losing? Could you fight in an unjust conflict and still be a noble person? Could you serve in Vietnam and not be involved in the kinds of atrocities reported by the press? Is there value in doing what your government asks, even if you don't agree or even if those at home seem overwhelmingly opposed to it? These questions and many others went unanswered. In the midst of our confusion about how to treat the returning veterans, the families of those who lost someone in Vietnam were even more isolated. This was not the conscious decision of a callous society but more a result of our inability to resolve the contradictions we faced. We have not reached the end of the questions, but we have reached the point of recognizing that we put the Vietnam veterans in an impossible situation.

Given this context, it is difficult to imagine a memorial that uses a single battle or hero to remind us of our presence in Vietnam or to represent and honor those who fought. Rather, we chose at last to honor—in a very personal way—those who served and to memorialize the men and women who died or are missing in action.

The memorial is a list of names. Etched on black granite walls are the names of the men and women who died or are still missing. The monument and people's reactions to it make little reference to the divisions that grew during the war. There are no designations of heroes here, no signs of atrocity, no signs of victory or defeat. Some of their names are marked by crosses to show those who are missing in action, but these marks do not distinguish draftees from volunteers, commitment from malaise or all of the shades in between. What we have done is to present our loss in a way that invites friends and relatives to ponder the names and memories of their loved ones in a setting that makes only slight reference to the larger questions—how and why they died, and whether it was right or wrong.

From the very beginning the memorial was a grass roots project, sponsored and funded by individuals rather than the United States government. The idea for the memorial may have occurred to many veterans, but when it hit Jan Scruggs after seeing "The Deer Hunter," he decided to do something about it. In 1979 Scruggs announced his plans to build a memorial to those who had served in Vietnam. It would be paid for from donations rather than government funds, it would make no political statements, and it would list the names of all

those who had died in the Vietnam conflict.

Once the location was decided upon, a national design competition was held. Although Maya Lin won the competition when she was only twenty, it was clear from the beginning that the organizing committee was dealing with a professional. Although others seemed to be having trouble visualizing the design, she knew exactly how it would look and what effect it would have on people.

Today people come to the memorial from all walks of life to search out the names of those they knew. In this process they confront the past and the possibilities of what might have been for those who died and for themselves.

Through the gestures of those who have visited the wall leaving precious items, touching the memorial, and remembering Vietnam experiences, we are able to see those who died or are missing as individuals. Many of the visitors to the wall are torn between loyalty to those who served their country and loyalty to moral issues. Some of these images are of people unable to move forward; others are of people in transition. All show the personal costs of war, regardless of politics. In this open, communal setting the extent of our loss in terms of those who have died, as well as those who live on, is made visible.

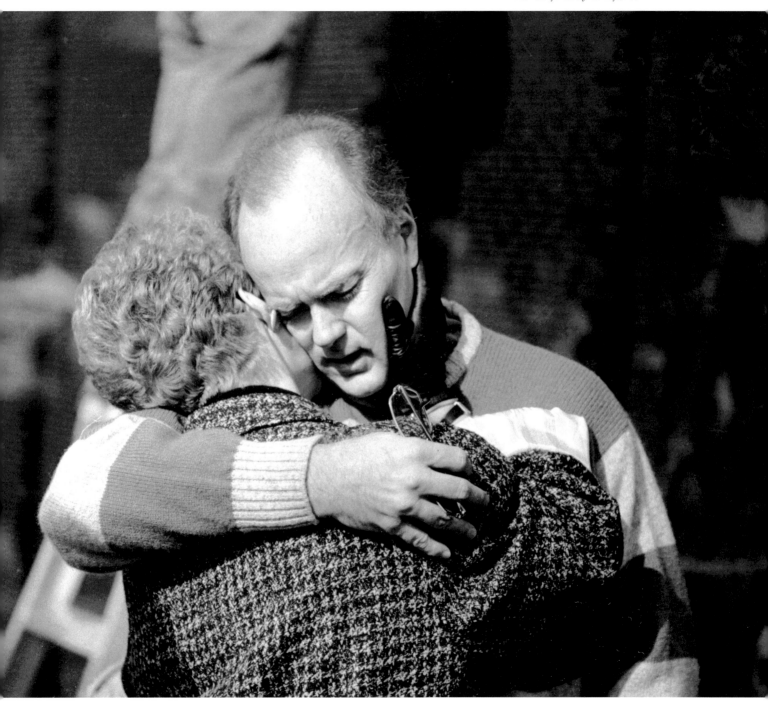

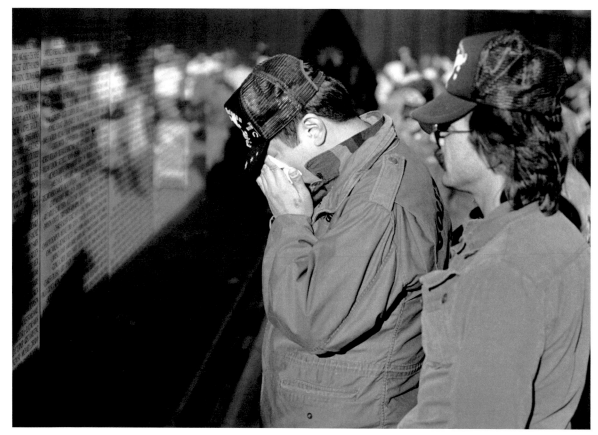

Man crying after discovering a name, 1987

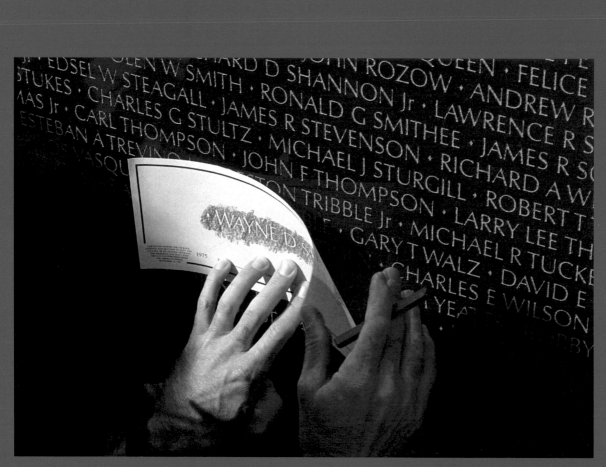

Ranger taking a rubbing of Michael Katakis' friend, Wayne Douglas Stigen, 1986

Wall 25, Line 91

Michael Katakis
Washington, D.C. 1985

In Washington, at the Vietnam Veteran's Memorial, I made my way to the books that hold all the names of the dead. As I turned the pages, I remembered him as he was and hoped somehow that his name wasn't there, knowing of course that it was, and finding it. Wayne Douglas Stigen, Chicago: W25, L91.

The Washington monument and the Capitol were directly in front of me as I walked along the narrow stone path next to the wall and its thousands of names. A man in his thirties stood in front of the wall, staring, a small boy at his side. They held hands and after a moment the boy looked up and asked, "Daddy, why do people go to war if they know they're going to die?" The man looked at the child and smiled sadly.

I didn't cry when I heard of Wayne's death. I think that I just got angry, then numb and finally silent. As I walked past the endless names, searching for Wall 25, I was numb and silent, the same feeling I had had twenty years earlier.

At Wall 25, I began to look for line 91. The black granite reflected my image and I clearly saw my face; then there he was. I stared for a moment, not at the name but at my reflection. I had changed; my hair had some gray and the lines around my eyes showed experience and wear. I reached out to touch and felt my friend was the same, still eighteen. Young people who die are frozen forever in time. Everything around the names would change in time. The people who would come year after year would see their reflections in the stone, their hair would gray, their bodies age. They would change, but all these names would remain as they were, forever.

I touched Wayne's name and began to cry. I cried for a long time and the granite reflected my sadness and release. I was finally able to say good-bye to my friend. I knew he would always be here.

"....There were no answers in my photographs, no deep intellectual analyses that gave new insights or profound conclusions, no eloquent tributes, just images of people left behind to deal with the past. The legacy of war that has so often been invisible does have to do with the people left behind, their lives, and how they move on. From this vantage point, as these photographs show, it is the living who haunt us as much as the dead." 1987

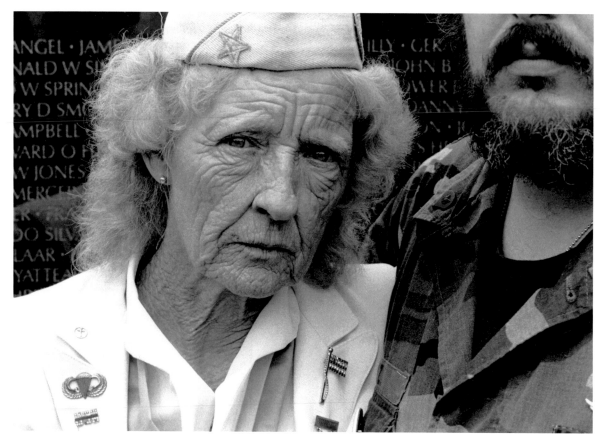

Evelyn Barbour visiting the memorial and her son's name, 1986

"The Vietnam War has damaged me for life, forever. I don't think it was a fair war. I believe if it had been a declared war a lot of our young sons would be home today. God bless you, America. Our sons fought and died for you."

Evelyn Barbour, Richmond, Virginia

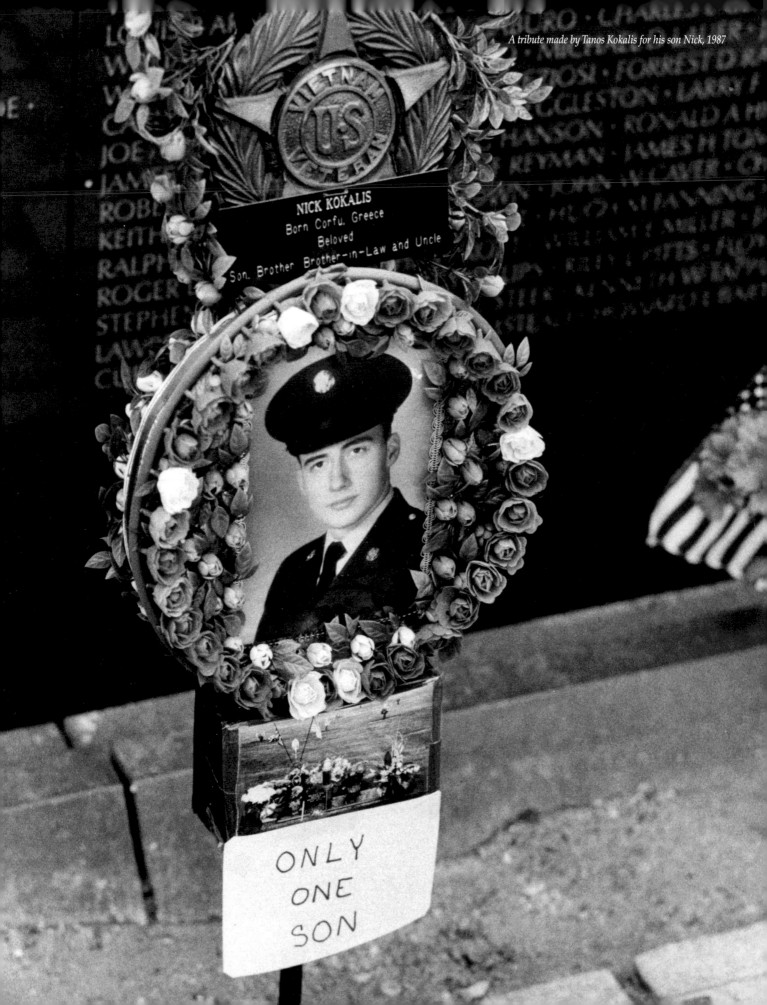

A tribute made by Tanos Kokalis for his son Nick, 1987

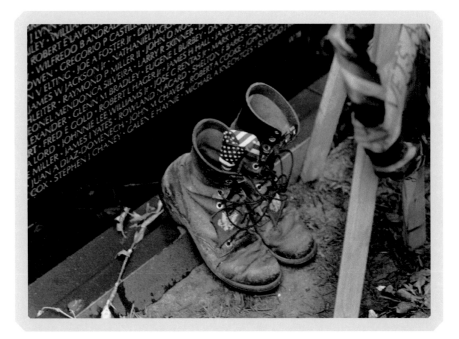

Combat boots with American flag left at the memorial, 1986

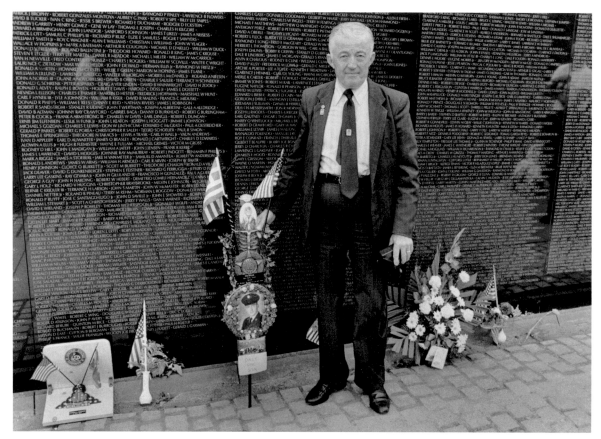

Greek immigrant, Tanos Kokalis, 1987

Katakis / Hardin *Photographs and Words*

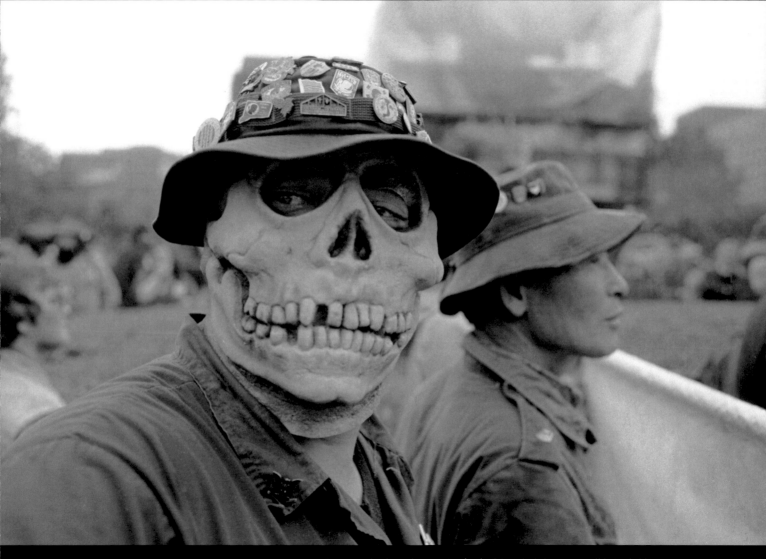

Veteran in death mask protesting for the POWs he believes are still being held in Vietnam, 1986

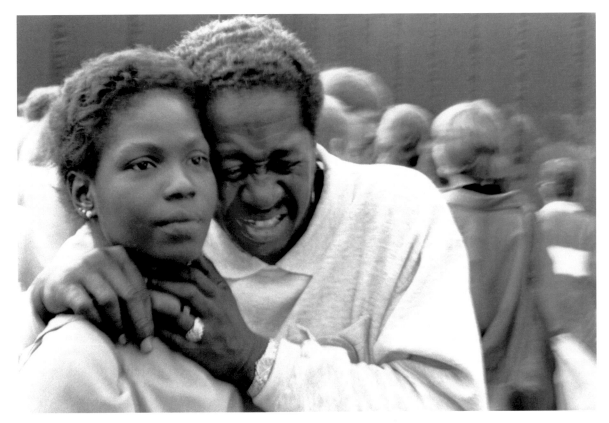

Veteran breaking down after seeing the names of the men he served with, 1987

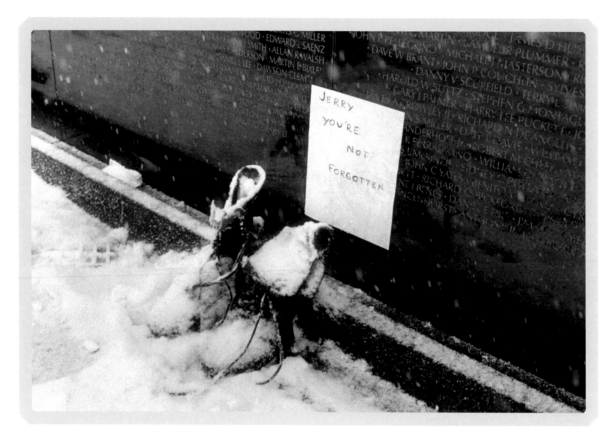

Empty combat boots left in the snow with a note, 1987

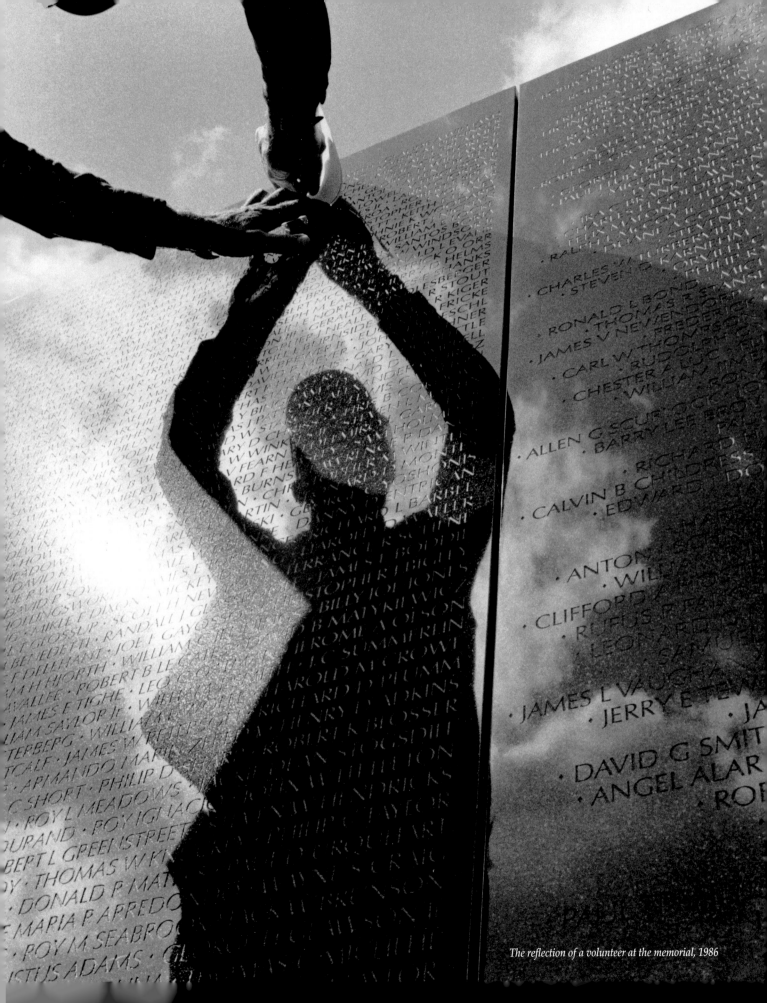

The reflection of a volunteer at the memorial, 1986

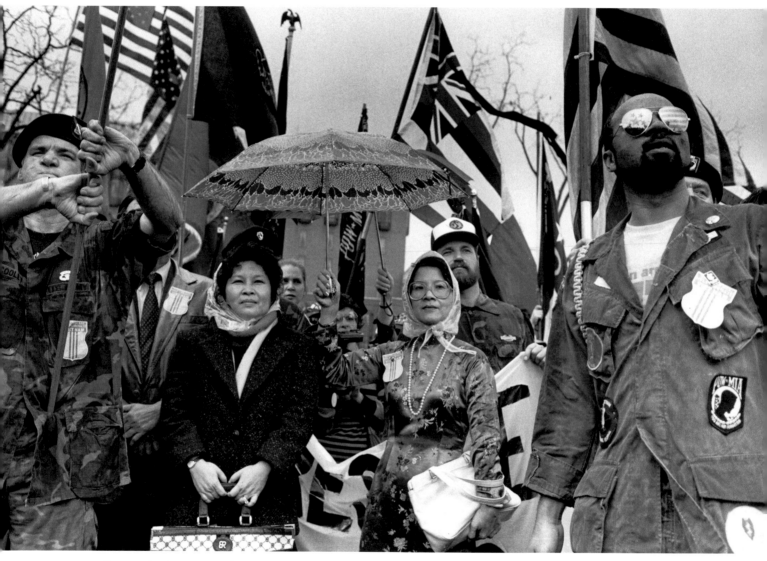

Veteran and civilian supporters during a POW protest, 1986

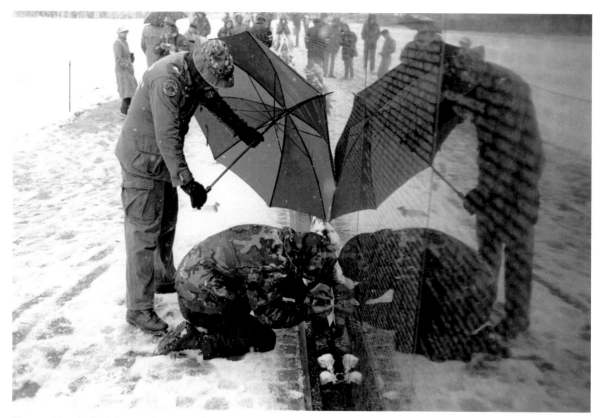

Veteran with umbrella shelters another veteran from the wind and snow while he gets the rubbing of a name, 1987

A couple searches for a name, 1987

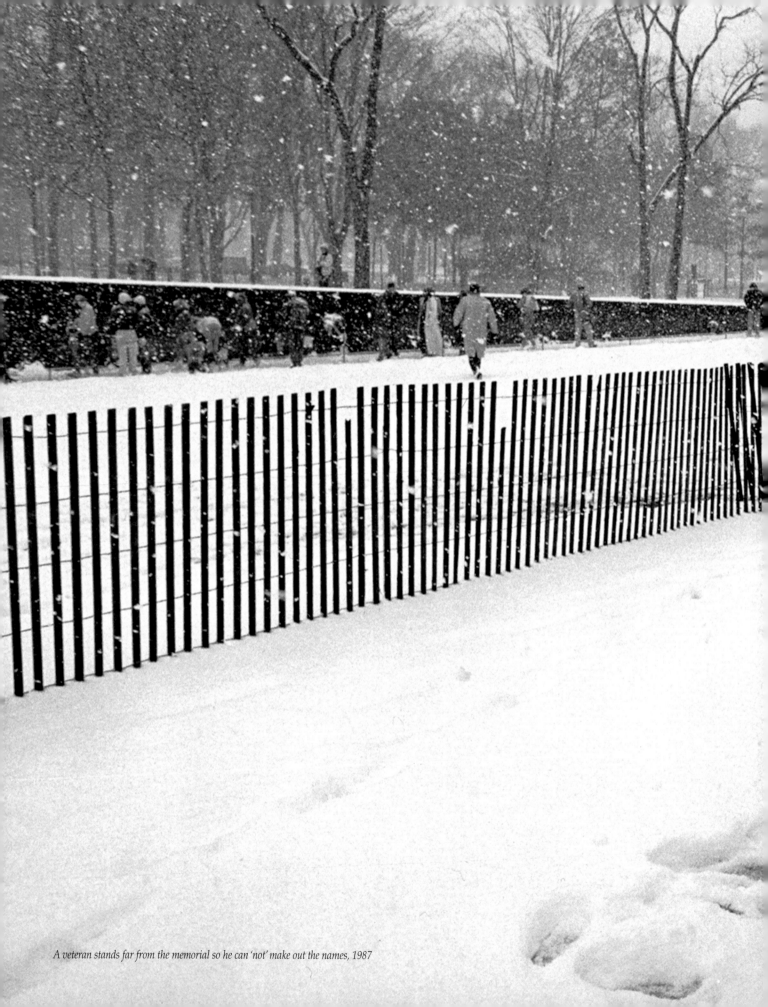

A veteran stands far from the memorial so he can 'not' make out the names, 1987

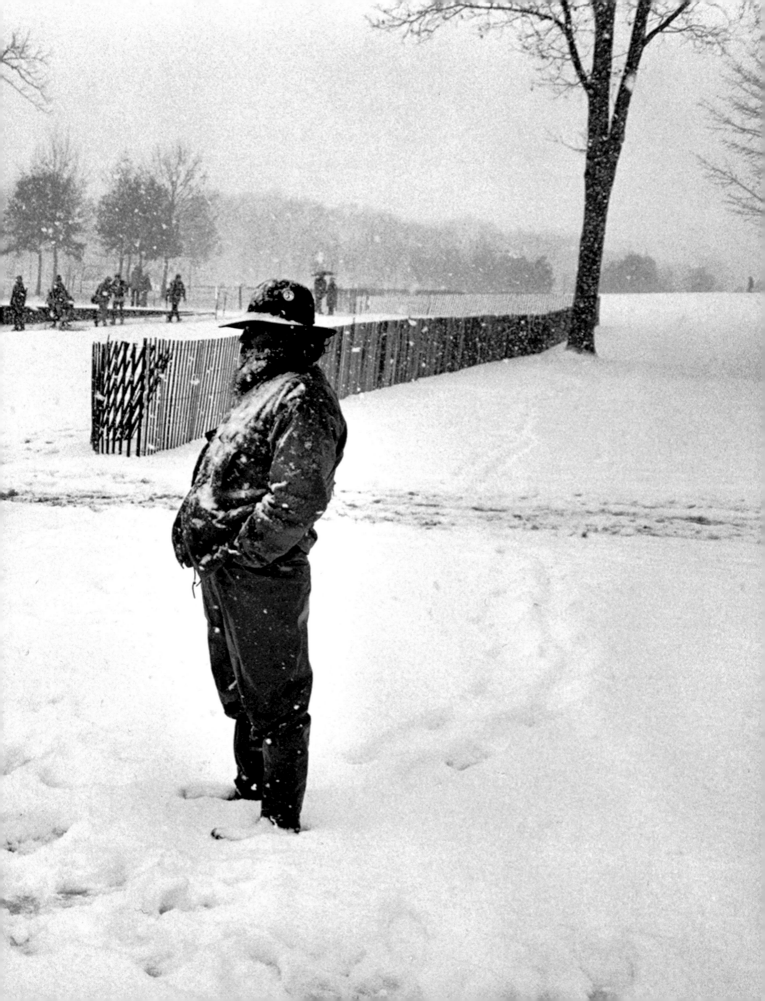

...OF LE FEBURE • ...TON • ROBERT L HUDSON • RICHARD C SCHOENBERG • ...JR THOMAS E BR...
DARRELL B RICKER • MICHAEL T MARTIN • ROGER L RITSCHARD • TOMMY...
ROBERT C RUNGE • ELISHA R SAINT CLAIR • VERNON...
MARTIN I ARBEIT • DAVID A BRYAN • VICTOR L ELLINGER • JAMES E ES...
MICHAEL D GEHRT • ROBERT C GOTTIER • PAUL G KELLEY • WARREN H MOB...
NORMAN F PALEY • ROBERT D PERRY • SAMUEL R SAITO • WILLARD ...
CHARLES R HAMILTON • MICHAEL N HUGHES • FREDDIE L LOCKHART • LAWREN...
SAMUEL L GANTT • EDWARD D BURKETT • RALPH HOWELL • DAVID E
WILLIAM CIP ARIAS Jr • MARVIN S ARTHINGTON • ROBERT L BAKER • ALLEN J BOD...
...MAS W GOSZEWSKI • PAUL T GILLASPIE • JORGE L JOURDAN-FONT • FREDERICK
...EDERICK M RADER III • MACARIO SANCHEZ Jr • DAVID C JAUREGUI • CHARLES ...
ALBERT HALL • FRANKLIN U BRECKENRIDGE • ROBERT J KOLY • JAMES B PO...
RONALD E SMITH • CRAIG N WARD • EARNEST WILLIAMS • GARY...
GEORGE BEEDY • JOSEPH C BLACKWELL • ELMON C CAUDILL II • FRANKLIN D D...
...MOND H GRAY • SAMUEL A GRAYSON II • ...ELBON M GREEN • RONALD P GR...
JACK HOGAN Jr • JAMES F SAXBY • CHARLES A JOHNSON III • ROBERT B JOHNSC...
WILLIAM A KETCHUM Jr • JON... • CHARLES J KOLLENBERG • LEE ROY...
...THUR J MENN • CECIL G MOYER • GRAYSON H NEWBERRY • DOUGLAS H PARR...
ROBERT J POLNIAK • JOSEPH A JACQUES • ROBERT D SCHNEIDER • BOBBY...
...MES C STARNES • JAMES E STUBBLEFIELD • RONNIE C TESCHENDORF • HARRY A...
ROBERT E YOUNG • CLARENCE E BAKER • ROBERT A BOJANEK • DOUGLAS S BR...
RAFAEL A DIAZ • GENE EDWARDS • FREDERICK L FIELD • ROBERT S...
JAMES D JONES • ROBERT G MOORE • JOHN C STRINGER II • BENJAMIN R NE...
...NETH L ROBERTSON • DENNIS M SMITH • FELIPE MORALES • ROGER W ANDERSO...
LAVERNE D COYLE • KENNETH E CRAYNE • THOMAS W FRECH • ERIC L...
WALTER D LAMBERT • ARTHUR W MACHEN III • JOE M PALACIO • RAYMOND B P...
...L STALLINGS • JESUS M BERRIOS-RIVERA • LEONARD P KUNSMAN Jr • JAMES H...
FRANCISCO VEGA • DAVID M BAUM • JOHNNY P GARCIA • LARRY E...
ROBERT L KING • SCOTT L SCHMIDT • JERRY D WALKER • PETER C BEHREN...
HENRY L CHAVIS • GEORGE C GREEN Jr • JAMES R HEIMBOLD • JERRY D...
...KERMIT L MATTHEWS • HOWARD J SCOVILLE • ...ED TO...
...SCHMERBECK • WAYNE L KE... • LEW • RANDY D RAY • ...LEE RO...
...NDRE... • ...ER Jr • STEVEN C WILLIS...

Ghosts in the wall. Visitors reflected in the memorial, 1986

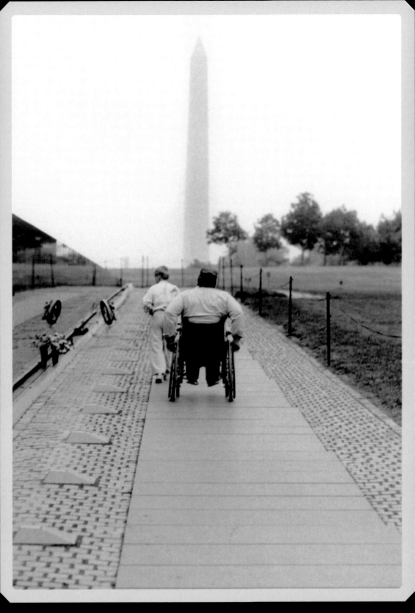

Disabled veteran and his son leaving the memorial, 1987

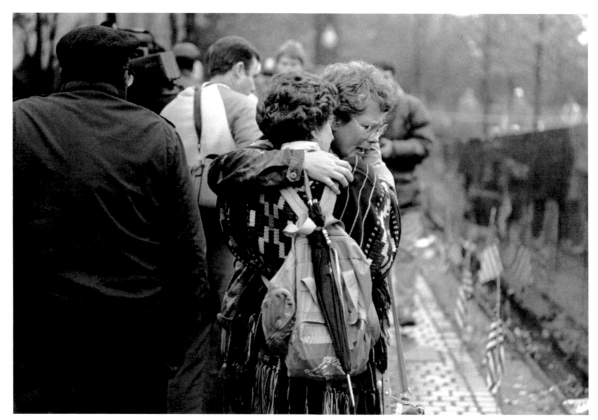

Two army nurses finding a name, 1986

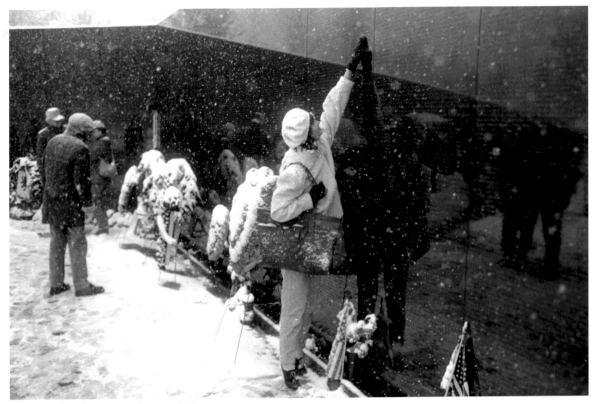

Woman reaching for a name in the snow, 1987

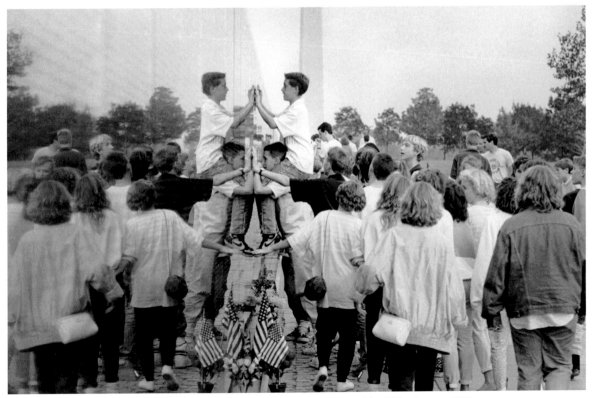

Schoolchildren assisting one another to get a rubbing of a name that was similar to one of the children's names, 1987

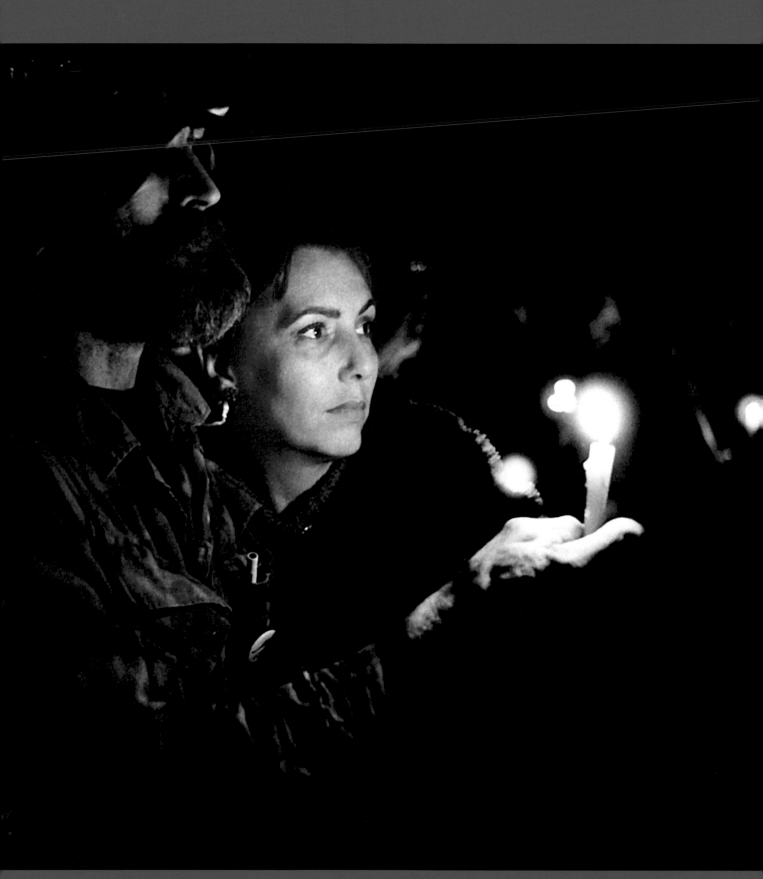

Candlelight ceremony for prisoners of war believed to be alive in Vietnam, 1987

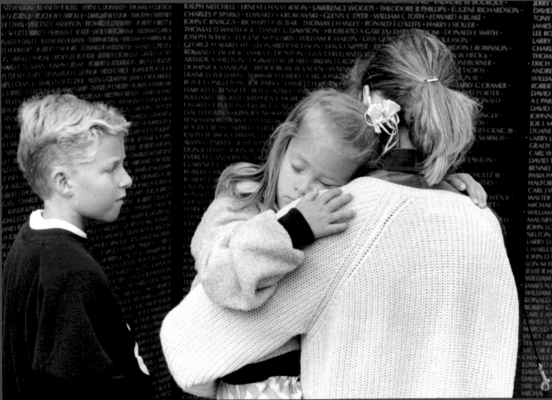

Mother looking for a relative's name, 1987

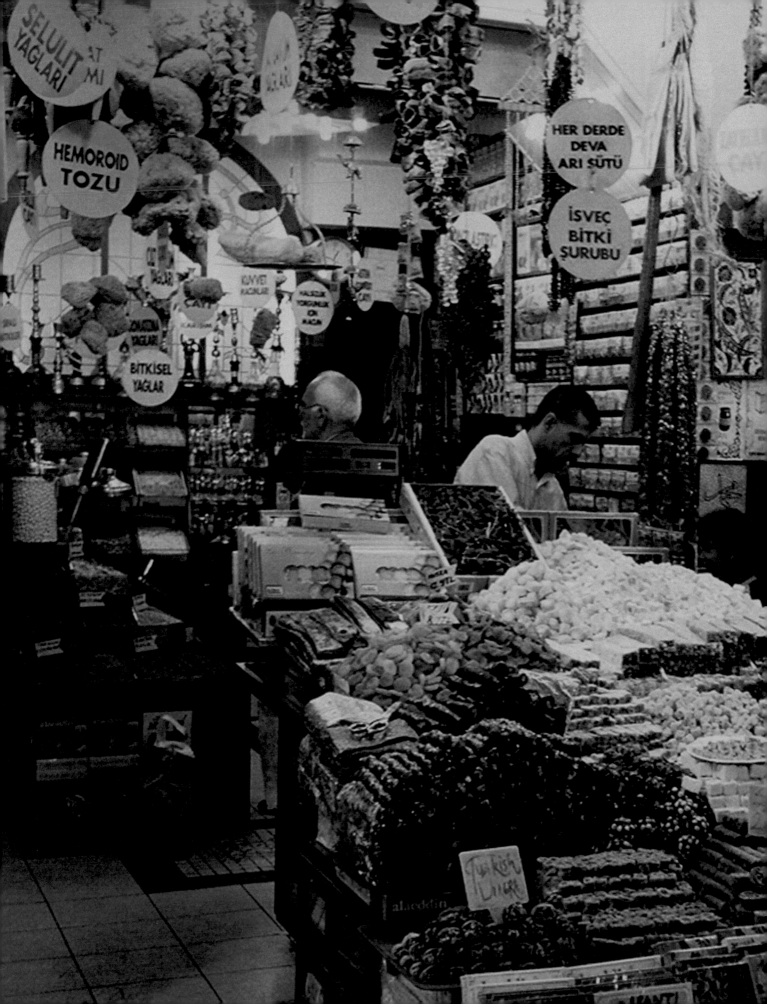

Artifacts

Witch finders and Choomas

Kris Hardin

A witch finder or chooma is known by his elaborate costume; identifiable by metal rattles tied to his legs. With each stamp of the foot, the chooma's movements are syncopated by the rattles and a puff of dust that flies into the air. Dance validates many of the important events in Kono life and a person who won't dance at a chief's proclamation or initiation ceremonies may not be trusted.

I interviewed one chooma who had been named the top witch finder in the area by a gathering of chooma in Koidu. He had been born in one of the small towns on Kainkordu road and went to school to Form 4, and at that point his father, who was a chooma, was dying. He was called to his father's bedside to say good-bye where he was given a secret medicine to drink. Following that, he spent two weeks in the forest not knowing who he was, where he was or what he was doing. He then had a dream to become a chooma and was sent to Guinea for training.

I had been told before that all choomas have witches, and that they can only work for good. Witches are gotten through dreams or by eating something that is secretly placed in their food. Eaten witches cannot be used by the person but are put in food to cause stomach problems and other illnesses. If someone has a problem (bad rice crops several years in a row, barrenness, or unexplained illness) he or she will call a chooma, who then gathers the witches bothering the person and convinces them to leave the individual alone. Such convincing takes place with dance and oratory. Many of a Chooma's songs have come from witches they have defeated, or a witch may trade his life for a powerful song in order not to be killed. Choomas are known for killing witches....

Section Chief celebrating in Kainkordu, 1983 Kris Hardin

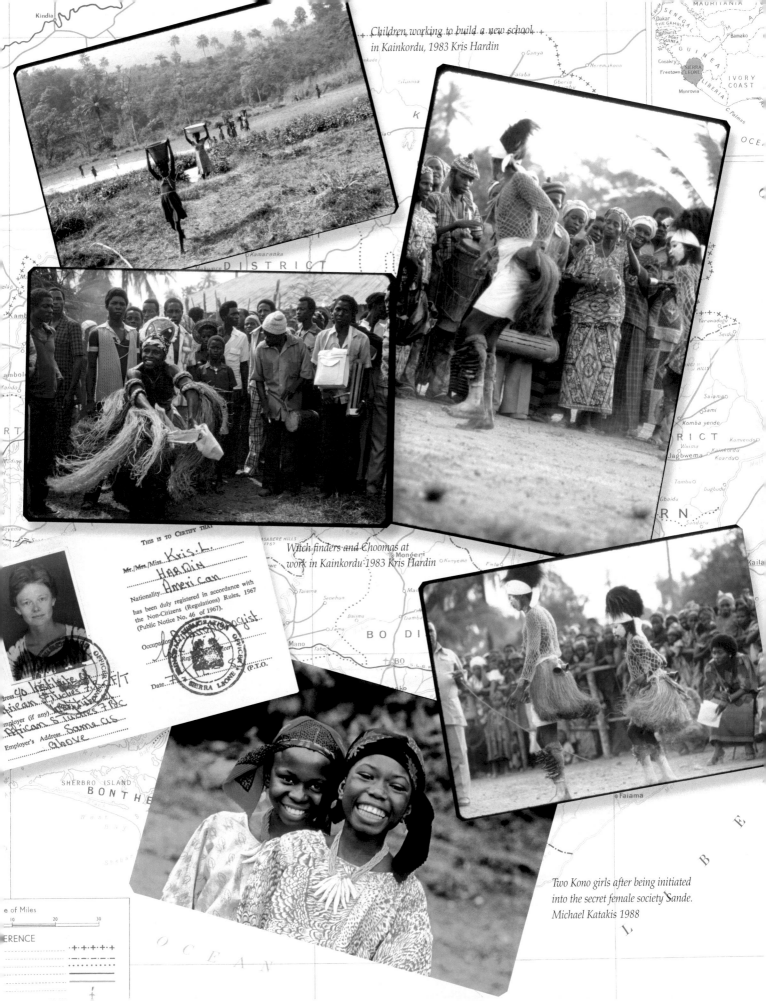

Children working to build a new school
in Kainkordu, 1983 Kris Hardin

Witch finders and Choomas at
work in Kainkordu 1983 Kris Hardin

Two Kono girls after being initiated
into the secret female society Sande.
Michael Katakis 1988

Narrow Alleys, Staring Eyes

Journal entry
14 October 2006
Fez, Morocco

I have really gotten turned around in the medina. I have stopped at a café of sorts to take a rest and coffee and collect my wits. For nearly two hours now I have been trying to extricate myself from the narrow alleys and staring eyes, but continually seem to be pulled deeper into a complex maze. I usually love to get lost in new places, in fact I do it on purpose most times. I head off in a direction, turn, and then turn again, until my bearings are good and confused.

Then, being lost, I begin to talk with locals as best I can. Being lost is a good starting point for conversation because, although people may see you as a curiosity, they will not see you as a threat. But for now I am tired and my senses are overwhelmed. There are scents of cumin, curry and varied spices that I cannot identify as well as burning wood or charcoal. A worker at the tannery gave me some herbs to hold under my nose so as not to smell the brutal odor of the ancient workplace. Visually, life is composing itself a thousand times a minute. There was the camel butcher making the camel head presentable and the sweets vendor who kept his eyes on me. My ears are tired as well from the endless sounds and whispers and commerce. I am tired, too tired to engage in conversation. I finished my coffee and walked back to what at first seemed familiar. No, just another strange narrow alley with partially covered women. I walk past and can feel their eyes.

"Salaam alekum" I say as I pass. There is not so

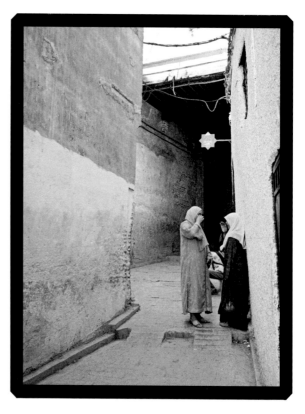

much a response as a murmur. Another alley and no, it does not look familiar. After forty-five minutes I stop for another coffee. There is a man with a small open market across from where I am sitting. Nuts and candies of all sorts are piled high in bins. Colors of red, brown, gold and green seem to explode in the diffuse light. I can see he is staring at me. I walk over.

"Salaam Alekum."

"Alekum Salaam," he answers.

"I'm sorry. Do you speak English?" I ask.

"Yes," he says with a smile. "I learned English in England. I went to school there."

"I'm sorry to be in your country and not speak

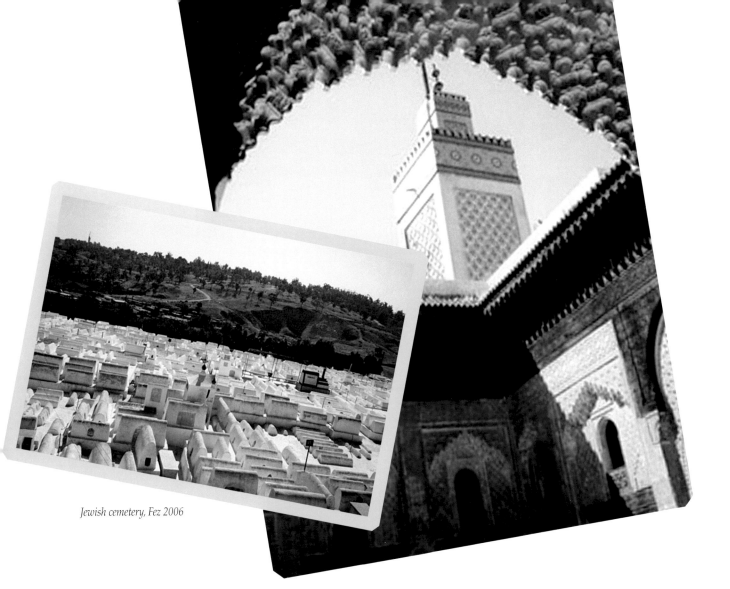

Jewish cemetery, Fez 2006

Arabic. It is a very difficult language, especially for someone like me who is not very good with his own."

"You are Canadian?"

"No, I'm American."

"Oh I'm sorry. Yes, times are hard now. Please have some nuts." He then offered me some sweets. Thinking of Ramadan I said, "No, thank you."

"Please, you are my guest and you are not rude if you take a gift and eat it at Ramadan. We make allowances for non-believers," he said with a wry smile.

We talked politics, religion and philosophy. He is a wonderful man with a sparkling mind. As we talked, I wondered if he were starved for conversation while surrounded by people who might not embrace his kind of open mindedness. When it was time to leave, I explained my difficulties in trying to find my way out previously.

"You are never lost in the medina," he said. "Look, let me show you."

Holding my hand he led me through an alley that seemed familiar and then one more. There was the arched entryway I had walked through hours before.

"Thank you," I said.

"I enjoyed our conversation very much. Please do return and remember, you are never lost in the medina."

As I walked out into the crowded street, I discovered that I was no longer tired, just eager to explore.
–MK

I Hope the Dog Wins

Journal entry

12 October 2006

Tangier, Morocco

I am wandering around the docks in Tangier. I have been watching six dock boys pestering a dog that has been minding its own business, seemingly waiting for someone. Finally, one boy takes a stick and pokes the dog as the other boys laugh. The boy does it again and the dog barks.

The boy starts to imitate the bark but the dog turns away. He then walks to another part of the street but the boys follow and throw the stick at him hitting him on the head. The dog has had enough. With remarkable speed the animal runs after the boys. At one point I see him grab a piece of pants from one of his now panicked tormentors. The police are watching this and laughing. The dog, very aggressive now, chases one boy to a chain link fence and the boy, with nearly super human strength, leaps sideways over the fence landing hard on his elbow, which yields a cracking sound. He yells in pain. The dog turns and takes off for the others. One boy amazingly jumps in the water and another runs on top of a car. Now the police come over and tell the boy to get off the car. It may be OK to be ripped apart by a dog in Tangier, but clearly it is not all right to jump on a car. I must confess I am cheering for the dog. I suspect the police are, too, as they walk by the animal and pat his head. The dog settles down and then calmly walks back to where he was before. I like Tangier. –MK

Adieu Tangier

Journal entry

20 October 2006

Tangier, Morocco

There are ghosts here like there are everywhere and the lingering presence of Bowles, Capote, Betty Hutton, the Beats and Burroughs has more to do with what I have read rather than a pitch by the city to promote those names for tourism. It is not like Hemingway's name in Paris which seems to appear everywhere to coax out the tourist's dollars or to elicit, in the tourist's mind, a golden time that has long since passed. No, Tangier is more subtle. Perhaps it has to be, for nearly none of the names connected with Tangier have the weight of a Hemingway, T.S. Eliot, Fitzgerald or Picasso and I like it that way. This city is what it is in spite of the writers, wonderful and dreadful, attractive and ugly, safe and dangerous. The city behaves as if it never needed the writers, and that would be correct. Burroughs and Bowles and the whole gang of intruders came to discover and take from the city. If it were not for what I had already read, I would have no sense of Hutton and her parties or Burroughs and his addiction. I would not feel Ginsberg's poetry or realize Bowles' élan. I would just be left with the city and, for a time, the city would be enough, just like Paris.

I have heard it said that there was a time when anything went in Tangier. It is said in the past tense, which has surprised me because as I have explored the darker sides of the city, I realize anything still goes. I love Tangier, not like Paul Bowles perhaps, for it does not speak to my heart enough for me to stay,

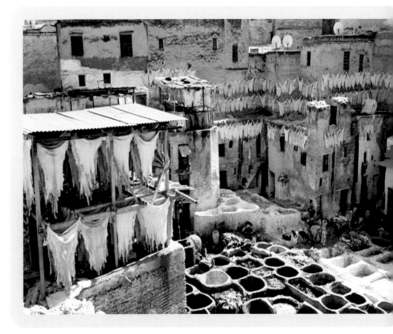

Dying vats, Fez 2006

but rather I love Tangier like a traveler who has had a tryst with a remarkable woman and who admits, at the end of the affair, that the arrival and departure were equally satisfying. I love its dirty streets and mysterious alleys. One could be murdered easily here while the city and the people behind the closed shutters above me would hardly notice. That is why I like this city. For good or ill it is a real place that seems unreal given the homogenized world we live in.

Tangier is what it is, unashamedly so, but time and modernity are pushing at the city's doors. Young people are arguing about faith and business and America. They are like young people everywhere, hungry and restless. In that regard they are just like the intruders who came before when they, too, were young. From my short time here I can see that they are coming still. This time, however, they may succeed in stealing what is left of her. –MK

"Painting and drawing has always helped me focus more intently on the place where I am, I then see things more clearly." Kris Hardin

Arriving at each new city, the traveler finds again a past of his that he did not know he had: the foreignness of what you no longer are or no longer possess lies in wait for you in foreign, unpossessed places.

Calvino

Happy Birthday and happy adventures in the coming year.
Love,
Kris

Journal Entry
28 March 2006
Paris

It's my birthday today and Kris has presented me with a beautiful watercolor of an Italian doorway that she painted after our time in Venice. I love it. She has also included a wonderful quote from Italo Calvino's 'Invisible Cities' which describes our lives so well. I see our travels, our years, in every word. –MK

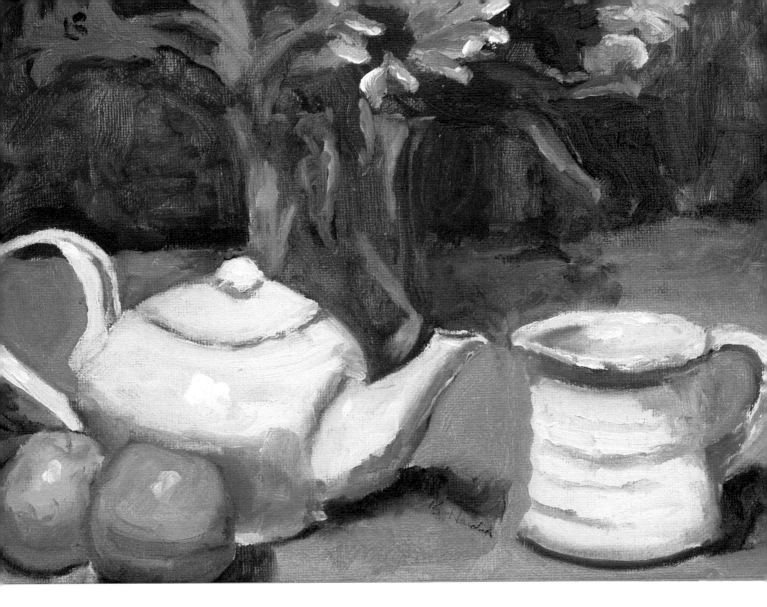

Journal entry
April 2007
Carmel, California

Kris has finished her lovely still life. The oil paint-
ing seems alive and bursting with a color that feels
early twentieth century French. I never cease to be
amazed by Kris' talents. Her pottery and writing, her
books and intellect along with her calm and mea-
sured approach to the world continue, after so many
years together, to fill me with wonder, and when I
remember her courage in Sierra Leone during the
dark days, my respect only increases for this remark-
able human being. –MK

Paintings and Drawings –Kris Hardin

The Sad Garden

Journal entry

18 August 1984

Crete, Greece

It is hard to believe that I am here with my father. He never spoke about Greece. I think I understand now. I'll start at the beginning so as to remember.

In May of 1941 people on Crete stared up at the sky as mushroomlike shapes floated to earth. The invasion of Crete by the Germans had begun. Among the witnesses were my father, his sister and brothers.

After the war my father immigrated to America and settled in Chicago.

When I think of my father, I think of his kindness and his gentle pride at being self-made. He never spoke of those days on Crete. He never spoke of anything that burdened him. My dreams took me to California but every Sunday we spoke. I was surprised one Wednesday when the heavy accented voice on the line said, "I'm going to Greece, would you like to come to see where I was born?"

So it was arranged. We would leave our cities, meet in New York and fly to Athens.

It had been nearly forty years since my father had seen his family.

He had started a new life in America seemingly never looking back. It was as though he had exorcised something painful or useless from his history. So I was surprised, when on the plane, he began to talk of what he remembered of his childhood. The trip seemed for my father a kind of mission or pilgrimage. I assumed there was some nervousness as well.

It's the same for all of us I suspect regardless of age. Going home reduces us to children. All of our achievements, experiences and futures pull us forward while our 'homes', the starting point, like the gravitational pull of a planet pulls us back to when we didn't know the world except in dreams. Odd, but I think we want to go in both directions, but finally must choose before we're torn apart. I thought my father had made his choices. I was wrong.

I do believe it's true that you can never go home again but I think it's equally true that you leave something of yourself back where you began. So it was for my father, who years before had sailed the sea to a new land. Now the past was pulling him back to where he began, back to where the secrets were kept.

Michael with his father George Katakis leaving for Greece, 1984
Photo by Ralph Elliot Starkweather

After one week in Athens, my father was happy and carefree. Greece can do that. I felt it, too.

In Piraeus we booked passage for Crete. In Khania, we were met by my cousins and together we drove up to my father's village. The little town with its dirt streets and olive groves contained no more than fifty people. Almost all were relations.

From a white house with bright blue shutters, a man appeared. He was about six feet tall and slender. He had a thick gray head of hair and a long, white handlebar mustache. Also, from the house came a woman dressed in black. She was very old and small and her black form in front of the stark white house made it appear as though she had been painted on the wall by some ancient hands. Soon four people were standing outside of the small house. In my life I saw my father cry twice. The first time was when my mother died. The second was on that day.

They all stood frozen and then they were together hugging and kissing.

That night the entire village prepared food. People set up tables outside along the dirt road. They carried on until the next morning. My father's little sister, Mary, sat next to me. She kept turning and smiling and under the table she held my hand. They laughed and argued but sometimes it would get quiet and they would just look at one another trying to take it all in, remembering how each had looked those many years ago.

Everything had been perfect but something was not said between them all. It was felt.

The next morning my father and I went to a cemetery. It was odd walking through a cemetery in Greece that had stones with German names. The names were those of soldiers who had fought and died here. Many dates showed that they had been young, some no more than boys. My father stepped in front of two stones. His face grew tight. The sadness was unbearable. Without a word my father betrayed his secret.

After a long time he pulled a handkerchief from his pocket and looked out over the surrounding hills. Then again he looked at the stones.

"It's like a garden," he said.

But watching my father as his mind wandered through time opening the once locked doors of memory, I thought it to be a sad garden whose only harvest was regret. –MK

Candy and Conversion

Journal entry

8 October 2005

Istanbul

Today I wandered Istanbul's large spice market. Most of it was indoors or I should say covered. What a place. Stalls everywhere with spices and candy and other items piled high. The colors of yellow, red and blue and sand even in the shadows seemed to explode. The people moving in and out of the stalls are amazing to watch as well. There was a woman fully covered in black that picked up some spices and brought it up to her veiled face to smell. One of her eyes caught my stare and she quickly put down the bright yellow powder but some of the powder remained on her veil and was oddly illuminated by its black background. It was strangely beautiful and made the stern clothing seem more feminine.

Hawkers tried to entice Kris and me to their stalls. We thanked them and strolled on. At one place a young man stepped out quickly and in perfect English said:

"Would you like to learn about Turkish Delight?"

The young man had such a nice presence and kindly manner that we agreed to step inside his stall and learn about that wonderful candy.

"You see," the young man said, "the Turkish Delight that all the other stalls hand out is made with sugar, regular white sugar. The finest Turkish Delight is made with honey. Here, first try this."

The man took us to the front of the stall where in a large bin there was the candy piled high.

"Try this," he said. "It is made with sugar. Now, re-member the taste.

Keep it in your memory."

Then he took us back inside and led us to the back of the small store.

Out of a very different enclosed bin, he pulled out three pieces of candy as an old man drinking coffee and smoking at a small table watched.

"Now," he said, "try this."

I bit into the small piece and the flavor was warm and gentle and rich and luscious. It was nearly sensual and as the young man had said, very different. The pleasure on our faces made the dour old man smile and he shook his head up and down and repeated,

"Good? Yes? Good?"

I looked at Kris and could see she too was taken with the wonderful flavors.

"Thank you," I said to the young man who now told us his name was Ali.

"You are from the United States?"

"Yes. We live in Paris a great deal of the time but when in America we are in California."

"I have been to the United States, in Boston. I was in school for engineering but I could not afford to stay so I returned to Istanbul to help my uncle with his business here. May I get you and your wife a coffee?"

"Thank you, that would be very kind."

Ali brought us two small cups of rich Turkish coffee

Hagia Sophia, Istanbul, 2005

Haydarpasa train station on the Asian side, Turkey 2005

Gelibolu Penninsula (Gallipoli), Turkey 2005

Sultan Ahmed Mosque (Blue Mosque) Istanbul 2005

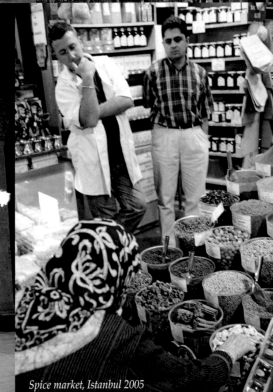

Café Makris, Istanbul 2005

Hagia Sophia

Spice market, Istanbul 2005

"I have always felt at peace and at home in places that have a bit of decay and are struggling, or thriving between the extremes of the past and modernity. Istanbul is such a place for me." Michael Katakis

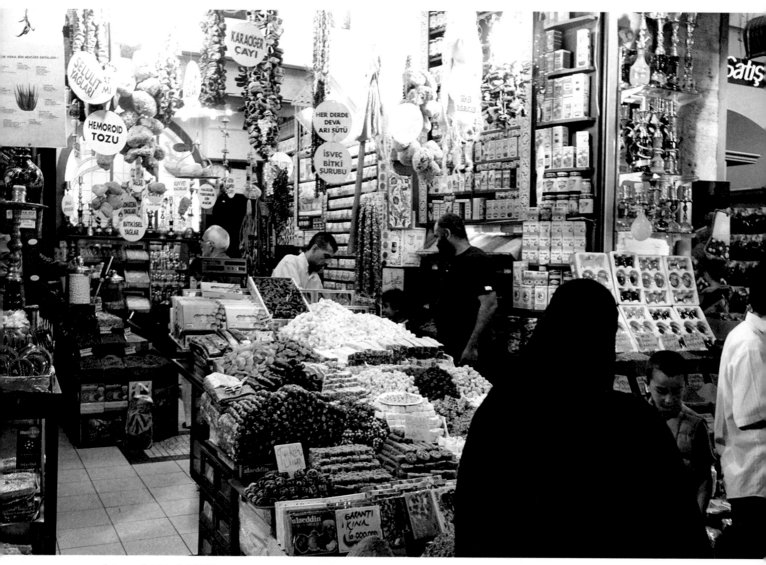

Spice market, Istanbul 2005

that was sweet almost to the point of undrinkability.

"Ali, are you trying to go back to America to finish your studies?"

"No. I will not return. At first I was very angry that I had to leave because of a lack of money. I was angry that America valued money so much and how it affected me. I was angry at a number of things."

"I'm very sorry that you had that kind of experience in America. It is true, I'm afraid, that America places too much emphasis on money sometimes."

"It is all right," he said. "I am no longer angry. I know that Allah had other plans for me. I had never been religious but then in America when things were not going well I met other Muslims who showed me some sites on the internet and I began to understand."

"Understand what?" Kris asked.

"I began to understand the one true path. You and your wife seem so kind and I am so sorry."

"What are you sorry about?"

"I'm sorry that you are both damned."

Kris and I were taken aback but not surprised by Ali's comment.

"Do you mean because we are not Muslims?"

"Yes, and it makes me sad because you are nice people."

"How do you know we are not Muslims?" I asked.

Now it was Ali who was taken aback and his face registered not relief but rather confusion.

"Are you Muslims?"

"No, Ali, we are not but for a moment you were not sure. All that you thought was that we were nice people. Is that not enough?"

"I wish it were for your sakes, but it is not. Here let me show you this website."

Ali showed us some extremist sites that wavered between conversion and penalties for a lack of conversion and the proper treatment of infidels.

"If I am an infidel in your eyes, can we still be friends?" I asked.

"I am still learning but I don't think so. How can we be friends and have such a gulf between us? How could I be happy knowing that a friend I love is damned?"

"What about women, Ali?" Kris asked, "Do you plan to marry?"

"Yes, I want to marry and have children. I will expect my wife to be fully covered to atone for my sins."

"Excuse me, Ali, but should you not accept responsibility and atone for your own sins?"

"No, you don't understand. Let me show you this website and you'll see how it should be."

As Kris and I watched this charming and intelligent young man move through the sites and go on and on about what Allah wanted and how it must be, I realized how the jackals of fundamentalism had preyed upon this person's disappointments and failures and convinced him that he was not responsible for any of that. It was Allah that had changed his path, which was now one of black and white. The jackals had removed all shades of gray and any doubt. As Ali went on and on, he seemed to get smaller and his voice more faint and I wondered which of us were truly damned. –MK

Regrets

Journal entry

5 October 2005

Istanbul

My time in Turkey has gone too fast. I have been here during the time when the European Union and Turkey were to begin official talks concerning Turkey's entry into the Union.

I was amazed at the number of women I saw wearing headscarves, especially younger women, but also surprised at the range of dress options. Everything from the face being covered in black to women with bare midriffs.

One evening while crossing the Bosporus on a ferry just as the setting sun shone on Istanbul's Mosques, I saw one young woman obviously influenced by the 'gothic look,' in black jeans and tee shirt with lace up boots and a button that read "Fuck your system." From that, I decided there is hope as long as such diversity is allowed. If that diversity disappears, it may be a sign of future difficulties.

As an anthropologist I often strike up conversations with people I come across and I will always regret not doing so with the young woman on the ferry. What did she think about the EU and what did her family say when she walked out of the house dressed that way? Did she feel pressured to conform to more conservative behavior? So many questions and not even a photograph taken and then, the moment passed. –KH

"Kris and I are oddly at home here. Why? The layers of history are seductive and the street's secrets reveal themselves slowly. You must take time here, much time."
Michael Katakis

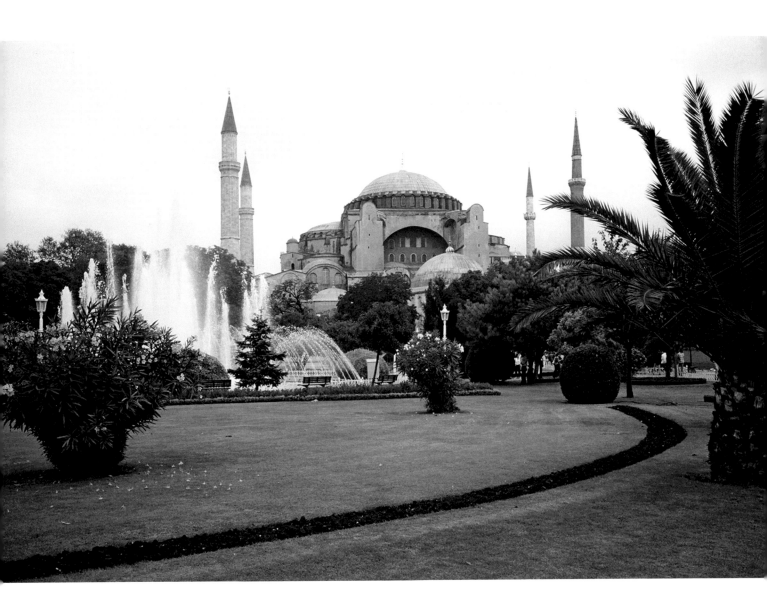

Hagia Sophia

Letter from Rapallo

18 July 2004
Rapallo, Italy

Dear Tanya,

….We arrived in Rapallo with Angus the dog and Thelma the cat on July 1…. The apartment backs up to a ravine (really just a gully) that runs up into the hills and then down to the Mediterranean. Depending on which way the breezes blow we smell the sea or the orange, apricot and lemon trees that line the ravine. There are paths along the gully and sometimes, in the early morning, I walk up to pick fruit that has been left on the trees.

At our end of the gully, closer to the sea, there are blocks of flats surrounding us, but the best part of the apartment and the reason I chose it, is the huge veranda that cantilevers over the ravine below. Michael writes there most mornings while I paint in the spare bedroom. We spend most of the day on the veranda. Thelma and Angus love it, too, and go in and out at will. We have breakfast, lunch, and dinner outdoors and have gotten to know our neighbors by sight. The older couple next to us reports when Angus has been barking, then, there is the woman on the other side of the gully who, on hot days sweeps her veranda topless in her bikini bottoms. We have yet to make her acquaintance, but we smile and wave, as does she. My favorite time of day is about 11:30 a.m. I know when it's time to start lunch because I begin to get whiffs of the wet, bready smell of pasta cooking in our neighbor's kitchens.

Let me give you an example of one excursion we

Venice 2004

had about the second week we were here. It shows the best and worst of Italy. It started on Tuesday evening as we tried a new restaurant. The place we went to was superb, slightly off the main part of the seaside promenade, but right on the water. The sun went down and we had magnificent views of Santa Margarita and Portofino as their lights came on. The breeze off the sea was cool and the lantern on the table gave off a lovely glow. We heard the gentle swells of the Mediterranean as we sat sipping spumante (the local sparkling wine) that our very charming waiter had brought us as soon as we sat down. We worked our way through plates of three kinds of carpaccio of fish. Next was spaghetti with clams that was out of this world! I went to bed that night so enchanted with Italy I thought I could never leave.

Next day, we boarded the train to Genova for the forty-five minute trip. So far, so good. That is, until two large women sat in the seats next to us and began talking for forty-five minutes straight, hardly taking a breath! Over the years I have developed the image of Parisian women as little birds, goldfinches or sparrows,

maybe, twittering and chirping away to each other as they walk down the street. I have come to think of Ligurian women however as crows—with heavy, loud, obstinate voices. When we first got here I often saw women walking arm in arm through the park or along the seaside promenade deep in conversation. I imagined they were discussing the finer points of Dante or perhaps a Verdi opera. I hoped that my Italian would someday be good enough to allow me to participate in these intimate associations. But, as my Italian got better, I realized the imagined intimacies were usually about what people were cooking for lunch or dinner that day or who had the freshest vegetables and meat in town.

.... Do I like Italy? It's wonderful and terrible. Usually the disorganization is charming. Sometimes it's debilitating. In truth—I haven't made up my mind yet, but the sea is fantastic, very warm right now. I wear goggles when I swim because of the salt and in the clear water I can see schools of sardines and anchovies swimming among the rocks, occasionally larger fish. It's very peaceful and calm—another world, a remarkable world to escape to....

Love,

Kris

Lake Como, Italy 1988

Somewhere in China / I am Lost

Journal Entry

July 1984
China

I have been wandering around China and have landed in this small village. I think it is maybe a hundred miles north of Guillin but I'm not sure. I left my map somewhere a few days ago (stupid) and have been winging it ever since. My Chinese, non-existent, and so far I have met no one and I mean no one who speaks English. I wonder how Marco Polo did it.

It is late in the evening here but the little main street (if I can call it that) is still alive with some assorted food carts. Earlier today I came by and saw this young boy selling melons. He had a mountain of them. That mountain is considerably smaller now and the boy appears to be tallying his day's earnings. I have tried to photograph it and hope it has come out. He has a kerosene lamp and it throws off a very bright light. The boy, with pencil in hand, is a study in concentration. As I have traveled through China, one thing is always apparent and that is how hard the Chinese work. In the many rice fields I have crossed I have not seen any machinery for farming. I have only witnessed ox and man. Can they really be feeding over a billion people this way with maybe some foreign food subsidies? If these people had more education and opportunity, I would not like to compete against them. They are amazing and have been very kind to me. Today I set up the camera in a rice field to take a self-portrait with a young Chinese farmer who was showing me how to plant rice. This kind young man and his family laughed as, repeatedly, my planting was not up to standard. I think I became the afternoon's entertainment. These lovely people fed me and offered me their bed. I could not keep up with their work ethic and I don't believe many in America could either. Their burden for the future, however, is the number of people. –MK

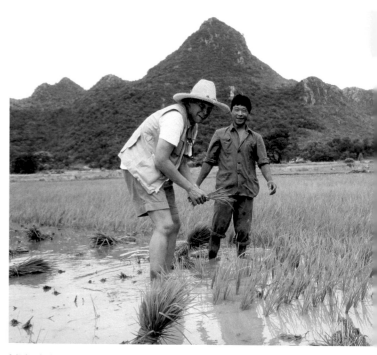

Michael planting rice very poorly somewhere in China while the farmer holds back a laugh. 1984

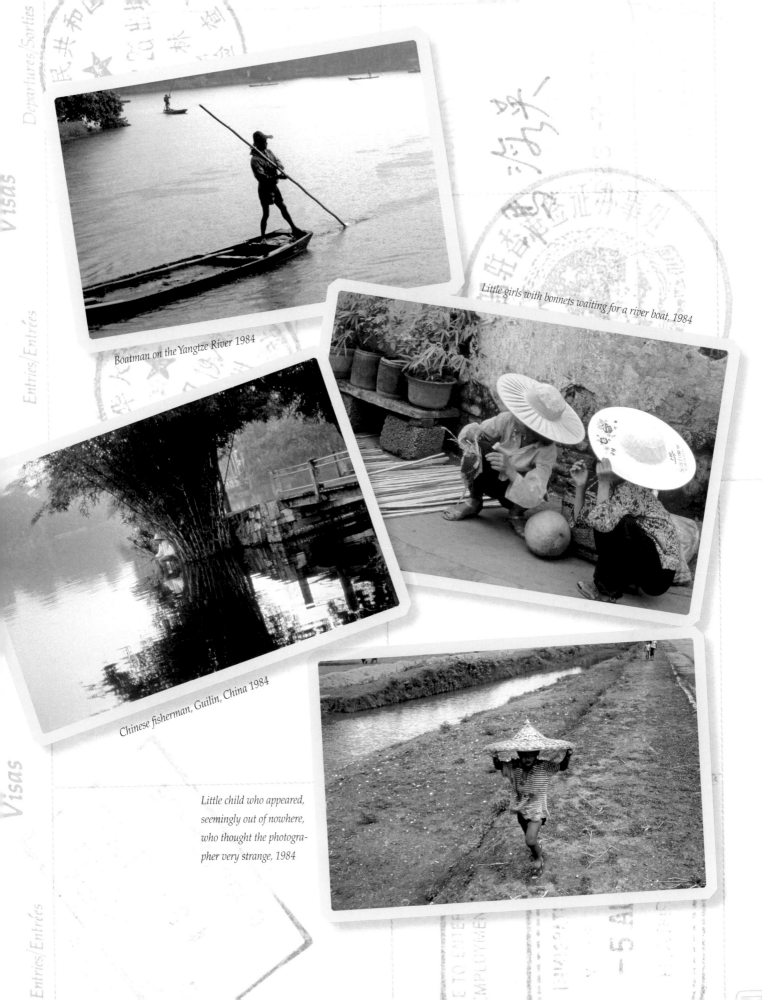

Boatman on the Yangtze River 1984

Little girls with bonnets waiting for a river boat, 1984

Chinese fisherman, Guilin, China 1984

Little child who appeared,
seemingly out of nowhere,
who thought the photogra-
pher very strange, 1984

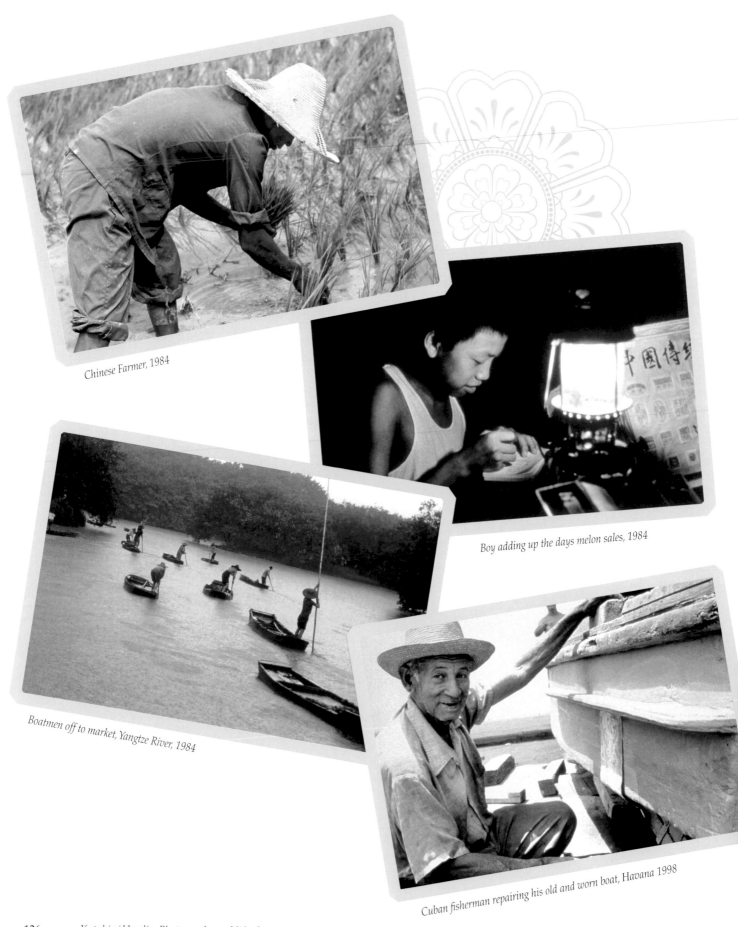

Chinese Farmer, 1984

Boy adding up the days melon sales, 1984

Boatmen off to market, Yangtze River, 1984

Cuban fisherman repairing his old and worn boat, Havana 1998

Still Lost in China

Journal entry

July 1984

China

I am still lost somewhere in the countryside and my frustration is added to by the fact that I am not really present. My mind keeps going back to the young woman I met. Her name is Kris. She is an anthropologist who has lived for years in Sierra Leone, West Africa, and now is at the Smithsonian. She is someone very special and I can't get her out of my mind. I wish I were not here or could get her out of my head. What is strange is that, for the first time a woman has lingered on my mind.

I must confess, however, that I like the thought of her here with me if only in memory. I want to cut my trip short and go to Washington to see her. How ridiculously romantic. –MK

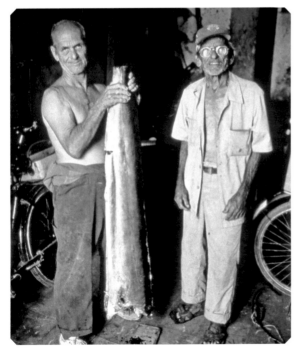

Cuban fisherman with their catch, Havana 1998

Above it All

Journal entry

2 May 1998

Havana, Cuba

I walked past the dark opening quickly and just caught a glimpse of the great fish on the floor. I turned around and stepped into the doorway.

Two old men were standing over the marlin which had just been cleaned.

The man who caught the fish seemed in his late seventies and was in remarkable shape. He wore thick glasses and a Chicago Bulls' baseball cap. In my very poor Spanish I was able to learn that this man had caught the fish on a hand line and then he showed me his simple gear and where the hook was bent. He took me outside and began to show me how to cast the line from the wooden spool. His smile and enthusiasm were infectious. I told him he seemed in fantastic shape and he laughed and pulled up his shirt and there was a hard washboard stomach that any health nut at Gold's gym would envy. For a moment I just stared at this joyful old man as he went on. I realized he was above all the politics and embargos, above Fidel and America, above the chaotic lives so many of us live. Here he was living in the moment. I suspect he had always lived in the moment. He again demonstrated how to cast the line and when I finally got it right he grabbed my arm and patted my back.

"Practice." He said in Spanish, "Practice. The pleasure is in the doing you know." –MK

Adieu Madeleine Levy

Journal entry

15 November 2006

Paris

It has been a day steeped in the past, a past that is also present.

I started my day early and went to Montparnasse cemetery. The information booklet describes the person buried in section 28, number 1, as *victime réhabilitée*. It is there that the rehabilitated victim Lieutenant Colonel Alfred Dreyfus is buried.

France I'm sure does not like to be reminded of the Dreyfus affair or their past and for that matter, their present anti-Semitism. The prosecution of Dreyfus in 1894 was an exhibition of France's institutional anti-Semitism and a prelude to the deportation of 76,000 Jewish men, women and children from France to German concentration camps from 1942 to 1944.

All around the Dreyfus grave are other large tombs, many are Jewish.

I was struck by the number of stones that gave the date of the deceased's deportation from France and to where they were sent. A number of them have the names Drancy and Auschwitz. I find this part of the cemetery unsettling and I become sad, agitated and a bit angry as the pictures of my own experiences in Sierra Leone begin to leach out of the part of my brain that usually keeps them tightly contained. I can never get my head around massive and wanton murder and I confess that I want to strike out at the aggressors and return them to the dust. I am always for the victim and unlike many of my fellow liberals I have no rationalizations to offer as to why the aggressor should not be stopped or killed. I believe

they should be killed. Just like today, I believe that talk with Sudan, while they engage in brutal genocide against black Africans is ridiculous and if I may, immoral. After WWII the world promised that genocide would not be allowed to happen again. Though it has failed in keeping that promise many times since, the world should keep its promise now and immediately start killing the janjaweed and the leaders in Khartoum if that is what it takes. I feel that is much preferable to another woman being raped or another child being murdered or a farmer having his eyes gouged out.

I suspect a family member of one of the deported dead here was very angry as well and could not contain that anger. A small sign has been placed permanently on a grave stating that the deceased had been deported by the French and murdered by the German barbarians. That sign, along with the graves, are a constant reminder of depravity and murder. It is also a cautionary tale stating emphatically that tyranny can never be negotiated or partnered with.

As I walked the narrow paths between the graves, I found myself in front of Alfred Dreyfus's grave again. I noticed the other family names on the grave. The second name caught my eye. Her name had been Madeleine Levy and she was the granddaughter of Alfred Dreyfus. I was to learn later that day (at the Mémorial de la Shoah, Musée, Centre de Documentation Juive Contemporaine) that Madeleine had been a girl scout and a social worker and

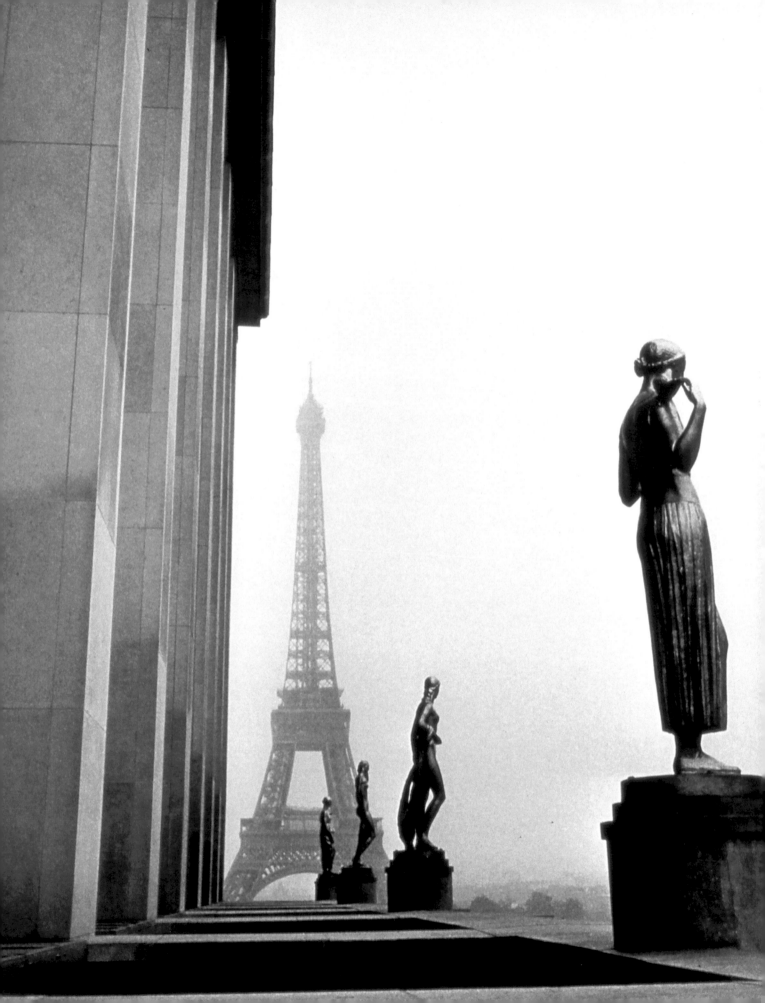

although her family had been warned of increased danger, Madeleine returned to Toulouse to work and to gather belongings from her family's apartment. There, she was arrested and sent to Drancy.

In 1943 Madeleine Levy was placed on Convoy No. 62 with eighty-three children whom she cared for on the trip. She arrived at Auschwitz and in a short period of time fell ill with typhus. She died in January, 1944, and it is said that she weighed less than seventy pounds at the time of her death. I traveled to the Memorial de la Shoah in the 4th *arrondissement* and a very kind lady named Alina Dollat took out her umbrella and in the rain helped me find Madeleine Levy's name among the thousands of names on the wall of remembrance. There she was, with so many others.

I went back to Montparnasse cemetery and as I sat by the grave, I thought of my first reading of Zola's *J'Accuse* and how moved I had been, not merely because of the writing but by the courageous action of one man who took on the army and state, the Catholics and the monarchists, and risked much personally in trying to right a terrible injustice. I believe Zola thought that the court martial did not just harm Dreyfus but was a societal cancer that had the potential of destroying his beloved France. Zola, in my view, was the best kind of patriot, one that does not goosestep in line just because the state says to. I think that Zola may have also believed that some stains cannot be washed out. He and John Donne had a bit in common.

With all of this history, it still took until 1995 for President Chirac to publicly apologize for France's deportation of the Jews in WWII and to turn over to the Shoah all of the prefecture registration cards of that period that kept track of the Jews in France. Why so long? After living here for a time and myself coming from a country that also denies and fabricates its history, I think I understand. Anti-semitism is alive and well in France as it is in many places in the world. But France has only grudgingly looked at its past. Some French friends tell me that it is complicated and that the truth is hard to find. I counter that sometimes the truth is very simple and that people who do not wish to confront the truth overcomplicate events so as to claim it an unsolvable puzzle and then dismiss it. The truth is rather straightforward. Occupied France rounded up and deported thousands of its own citizens to concentration camps where the vast majority were murdered.

In Sudan the truth is quite simple as well. Men, women and children are being raped and murdered for what little they have and the color of their skin and the world is doing nothing, as it did nothing in Rwanda and Sierra Leone.

I have always believed that history is not in the past. It keeps rolling in front of us and we keep running into it. Now, we are running into history again. So, I'm not surprised when I talk to my Jewish friends in Paris and they tell me that they are always prepared to leave when things get more difficult. Some say they are scared. Others say they see familiar signs that cause them to worry and also there are the Muslims who reside in France that the government seems frightened of and all too willing to placate. The key here is that my Jewish friends are worried.

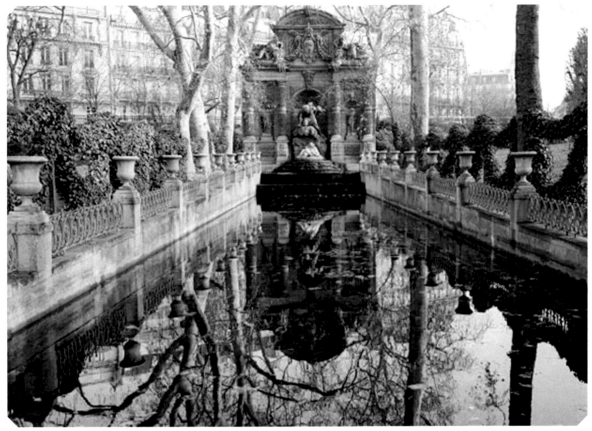

Luxembourg Gardens, 1993

For me, they are like the canary in the cage down in the mine. More sensitive to their surroundings with a history that demands vigilance.

Looking down at the map and plan of the cemetery, I saw one last indignity. I realized that Alfred Dreyfus' name was incorrect. It was listed as Albert Dreyfus and had his rank as captain. France should be reminded again, and always that here lies, Lieutenant Colonel Alfred Dreyfus, Knight in the Legion of Honor

Born: October 9, 1859

Died July 12, 1935

–MK

ANGELA SUSAN PEREZ
WORKS FOR CANTOR FITZGERALD
101ST FLOOR
TOWER 1

LEASE CALL WITH INFO:
914.803.1040
914 260 5446

Troubled Land

12 days Across America

Olga Morse
Mexican American, retired Air Force Veteran
Bozeman, Montana,
Saturday, September 15 3:02 p.m.

"The customer said shut the fuck up and go back to your own country. What country would you like me to go back to I said. Sometimes I forget that I'm different."

T. E. Lawrence in the Hejaz

Journal Entry

11 September 2001

Bozeman, Montana 11:39 p.m.

....today hard terrorism hit soft terrorism and, as is always the case, many innocent people have died. Some reports are now saying that thousands may have been killed but I am sure thousands have been killed.

It has taken the better part of the day for me to bridle and repress my own anger and now I worry that Americans will overreact quickly and carelessly.

What is needed now is calm, intelligence and patience. We should focus on families that have been devastated and care for the wounded and simply attend to the immediate needs of our fellow citizens. I know a response will have to come but it must be a thoughtful and measured response, not one born of nationalistic heat. In the coming days we will have the world supporting us and offering help in ways that just a day before we could not have imagined. It is imperative that we take that goodwill and let the world surround us for a time with care and concern for that, in itself, will be one of the great blows to the terrorists, they will have moved the world closer to us and to each other and we should not squander or take that for granted.

On the other hand if we do act carelessly we shall proceed down a road that will escalate and we will lose our way in a Muslim world that we do not understand and that lack of understanding will pull us deeper into a Middle Eastern quagmire that will, for many years I suspect, be hard to extricate ourselves from. The cost of it all will be thousands of American and other's lives.

We must also be very careful and vigil about pressures coming from our own shadows that will want to accelerate the call for action. Many corporations will see this as a great opportunity for increased profits from public coffers and they will be pushing the leaders, from behind the scenes to move forward quickly under the guise of patriotism. Many interests will now converge and I hope that the journalists will stay focused and resist falling into patriotic jingoism themselves.

What we need now is neither bravado nor swagger. We need cool, thoughtful planning and above all restraint. Mr Bush has much on his shoulders. I hope that he and us are up to the task, but I don't know. I hope our leaders have read Lawrence. –MK

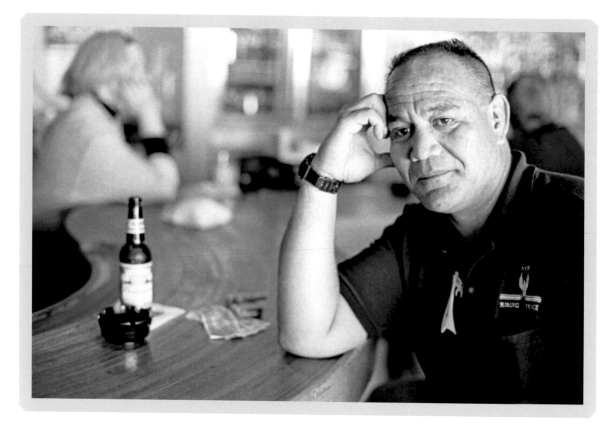

Leslie Rahirit Toia
Trucker from New Zealand, Monte Carlo Casino
Billings, Montana
Sunday, September 16 1:29 p.m.

*"It opened the world's eyes up to what terrorism
is. The world had a taste of what it would be like
without America."*

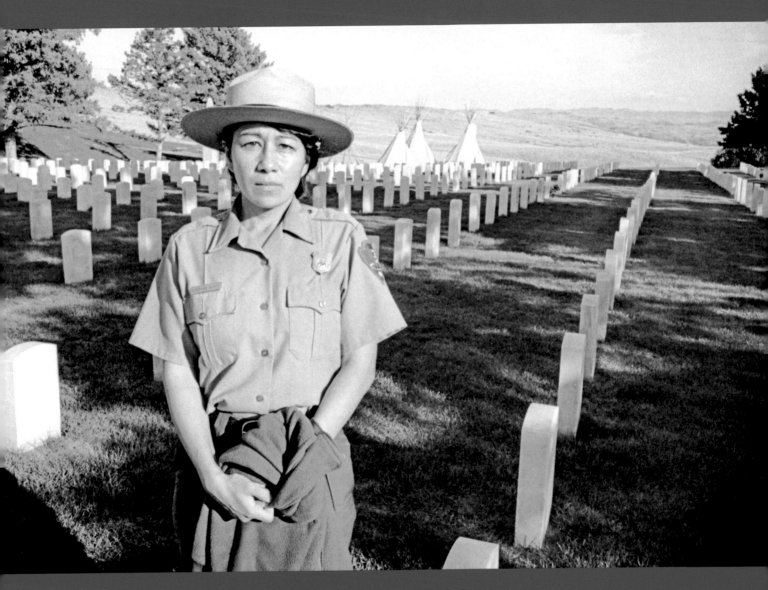

Lorraine Woody, Ranger
Little Big Horn Battlefield
Hardin, Montana
Sunday, September 16 4:37 p.m.

*"I'm very sad. I'm a native New Yorker. When I heard
I wanted to go home. I just wanted to go home."*

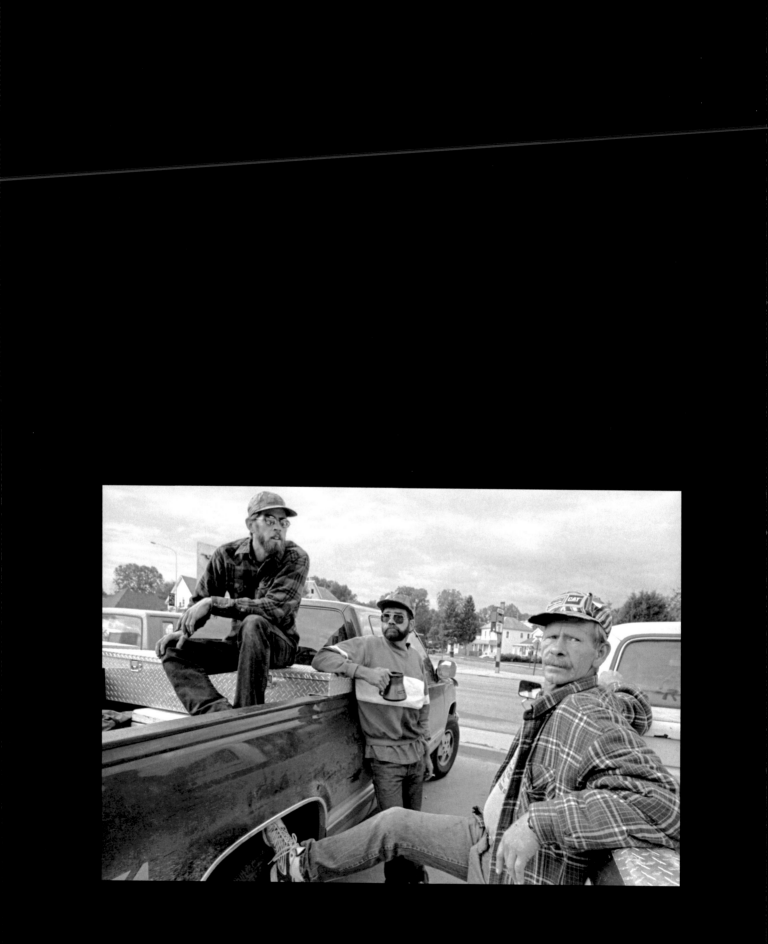

James Kethman (right) Kelly Chandler and Clay Forni
Construction Workers
Sheridan, Wyoming
Monday, September 17 8:42 a.m.

*"Its time that we as a nation support our country,
military and veterans." James Kethman "Foreigners
should not invest in the U.S." -Kelly Chandler*

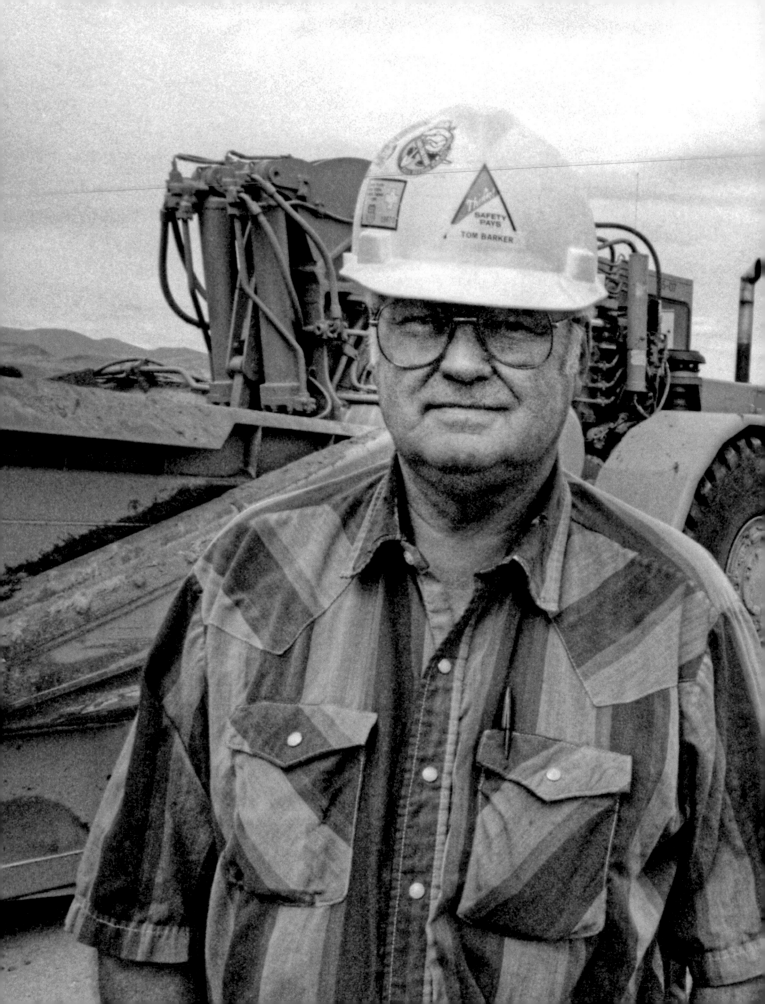

Tom Barker
Heavy Equipment Operator
Somewhere in Wyoming,
Monday, September 17 12:19 a.m.

*"Run their ass out of the country. We don't
need the rag heads here. The American people
better wake up. Too many foreigners coming in
that we're not checking. Its going to get worse."*

Journal entry
20 September 2001
Chicago

I am finding some good and thoughtful voices but it seems that they are few and I am filled with a great unease. I cannot find a center in the country or, in the people themselves, and the feeling is one of that 'we' are not in this together. This is a troubled land and has been for a long time, but now, as I focus much more intently on the people and what they are saying at this dreadful and historical time, I have this terrible feeling in the pit of my stomach that I still cannot face, even though I know it to be true.

The United States is not a country, it is a store where everything is for sale, every ethic and principal and friend. I suppose that the thin veneer of our repetitive pronouncements to the world and ourselves about human rights and freedom and democracy have lulled us into believing that that is in fact who we are, but that is untrue. At our core, regardless of what we say, we seem to care for nothing as much as we care about money and commerce. Again, to be sure, there are enlightened, decent and thoughtful people here but they too are afraid for fear is everywhere. And now I think there may be cause to be afraid for when people, any people, take leave of their reason and rally round a flag, the worst of us moves in under the guise of patriotism and then profits greatly from unspeakable misery. I am getting the feeling that we are now standing on such a precipice. –MK

Journal entry
24 September 2001
New York City

Finally I have found America, the ideal of it, the best of it. I think Steinbeck said that New York was no more America than Paris was France and he was right. In the midst of such tragedy and sadness I find New Yorkers magnificent. They are watching out for each other. I could not understand for a day but finally realized that the city was quiet, no horns honking and people treating each other with care. There are posters of the missing everywhere and the pictures of young and old, black and white, brown and Asian all together on walls show an America that is, in death, inclusive. The New Yorkers have an edge that I love. In spite of all of this misery they still have their dark and mordant irony and humor. In this sea of tragedy I have not heard, as I did in other parts of the country, people speaking about "getting people" or striking back. What I see over and over again are many small kindnesses being exchanged between people. Those kindnesses act as a balm and expand into even more kindnesses. These people are simply magnificent. They are the best of us. –MK

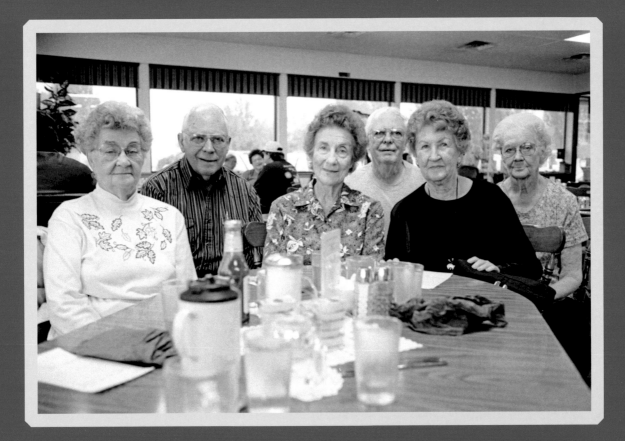

James and Geraldine and Charles and Allegra
Holloway
The Breakfast Nook
Rapid City, South Dakota
Tuesday, September 18 8:28 a.m.

*"You cannot punish people of any race or national
origin. We should only punish the guilty. All of
those people are in our prayers." -James Holloway*

James Lembley
Owner KSDZ FM radio
Gordon Nebraska
Tuesday, September 18 2:30 p.m.

*"I put up that flag yesterday with a star hand
drill. With every blow I was hitting Bin Laden
between the eyes."*

Mike Barnett and Bud Evans
Ranchers
Merriman, Nebraska
Tuesday, September 18 4:10 p.m.

"It may be New York but we're all Americans."
-Bud Evans

*"I think this is the time to declare war. Terrorists
threats are no longer threats."-Mike Barnett*

Ahmad Ghosheh
Village Inn
Omaha, Nebraska
Wednesday, September 19 3:10 p.m.

*"You have to be just. God is for the just not
the mighty. To the people of the Middle East
I would say learn what Islam is teaching you,
not what some muslims are teaching you."*

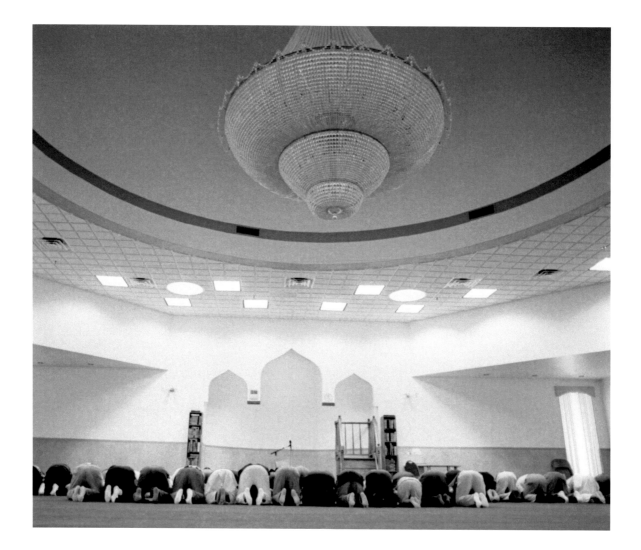

Midday Prayers
Outside Chicago
Thursday, September 20 5:00 p.m.

Dr. Seema Imam (right) and Kausar Ahmad, Muslim
Americans for Civil Rights and Legal Defense office
Hickory Hills, Illinois
Thursday, September 20 7:30 p.m.

"We are under siege domestically." Kausar Ahmad,
"What kept me home was my anger." -Dr. Seema Imam

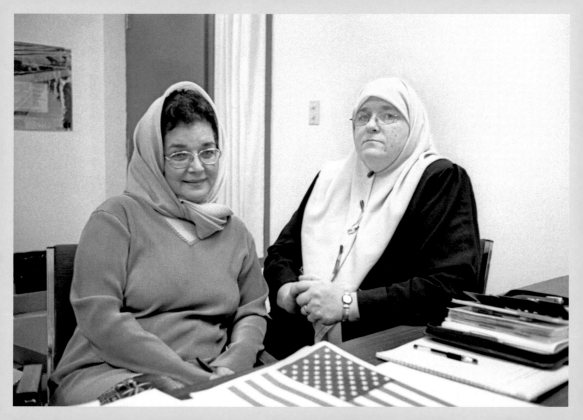

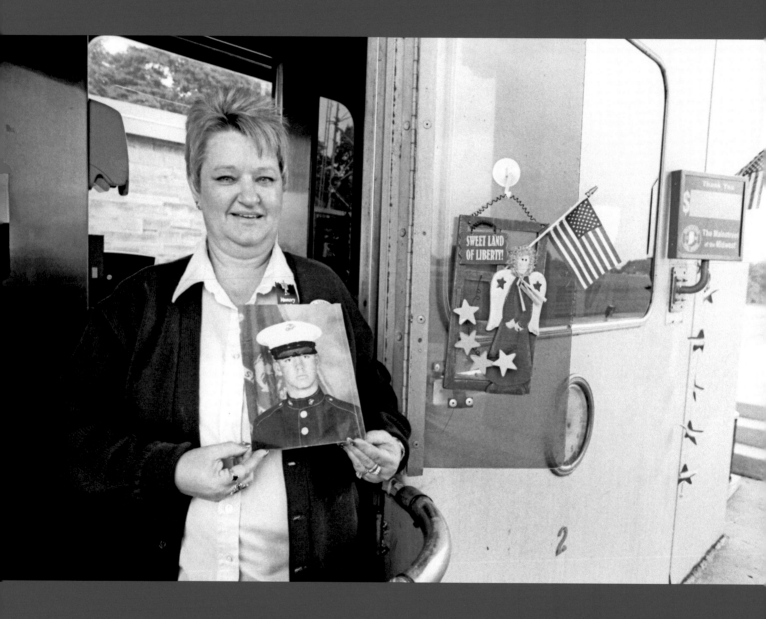

Anita Stalter, Toll booth operator, Exit 107
Middlebury, Indiana
Friday, September 21, 11:01 a.m.

"My son Dustin is a marine. I'm very worried about my son. Hope that he is home in January. He's having a son."

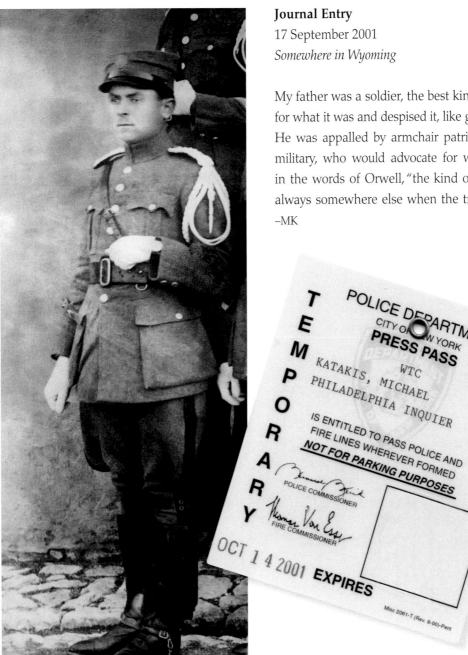

Journal Entry

17 September 2001

Somewhere in Wyoming

My father was a soldier, the best kind. He knew war for what it was and despised it, like good soldiers do. He was appalled by armchair patriots, civilian and military, who would advocate for war while being, in the words of Orwell, "the kind of person who is always somewhere else when the trigger is pulled."

–MK

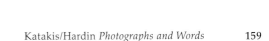

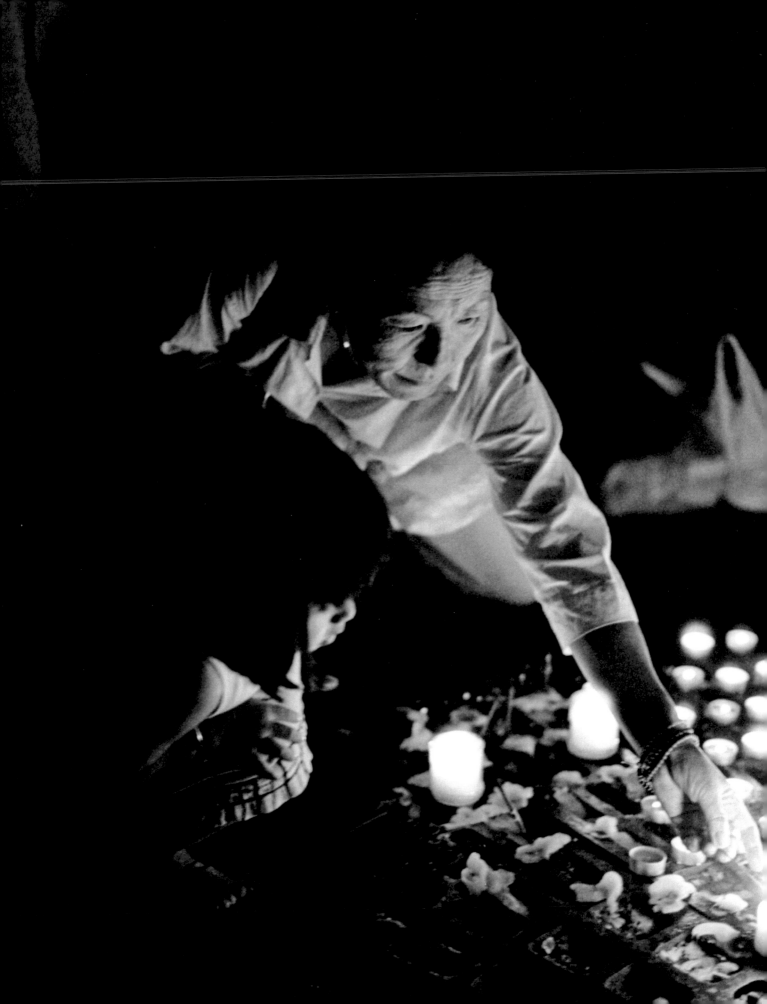

"I arrived in New York late on the evening on Sunday, September 23. I was very tired but went to Union Square where I was overwhelmed by the missing posters and candles. This was the first photograph that I took in New York."

Union Square, New York City
Monday, September 24 9:45 a.m.

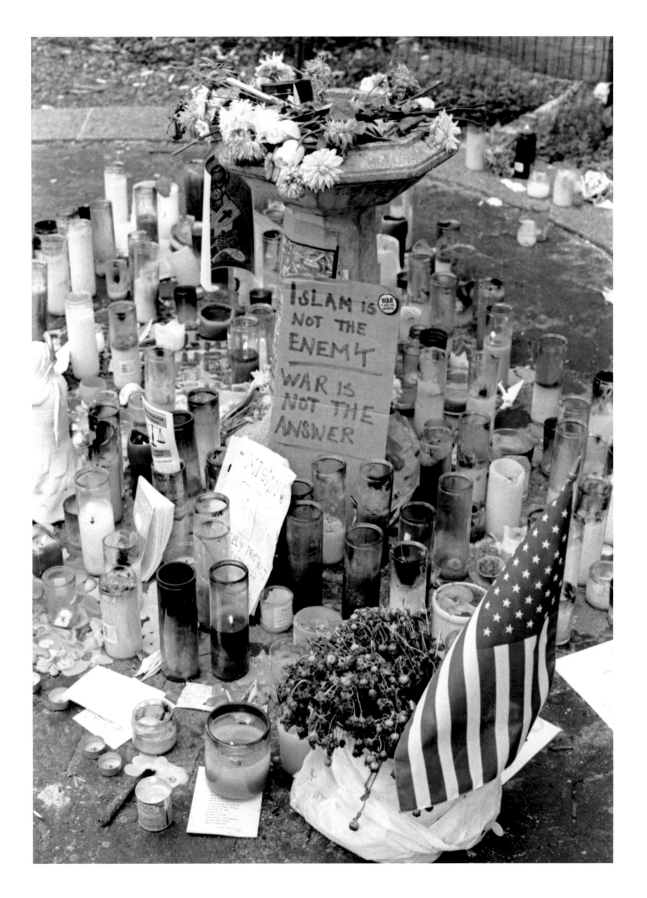

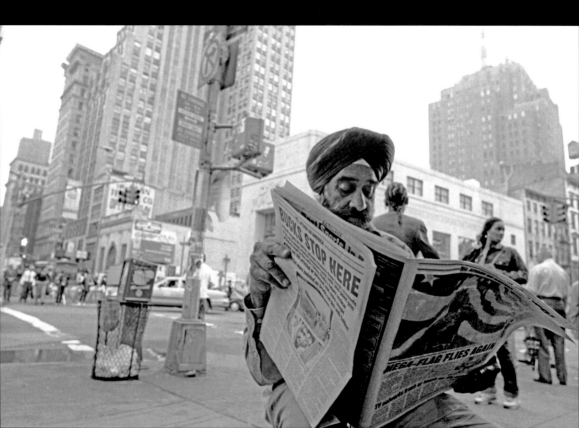

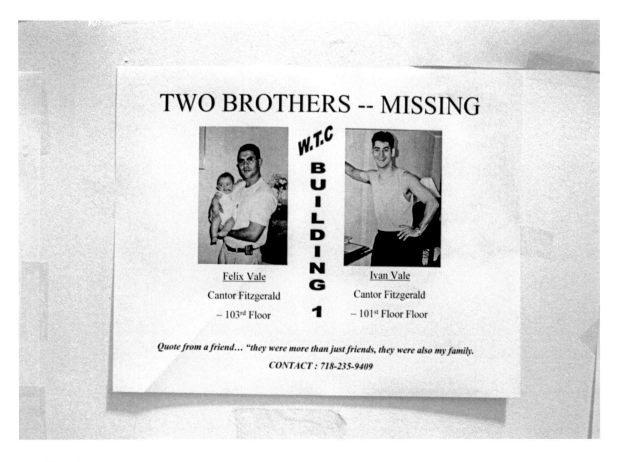

New York City
Tuesday, September 25 11:30 a.m.

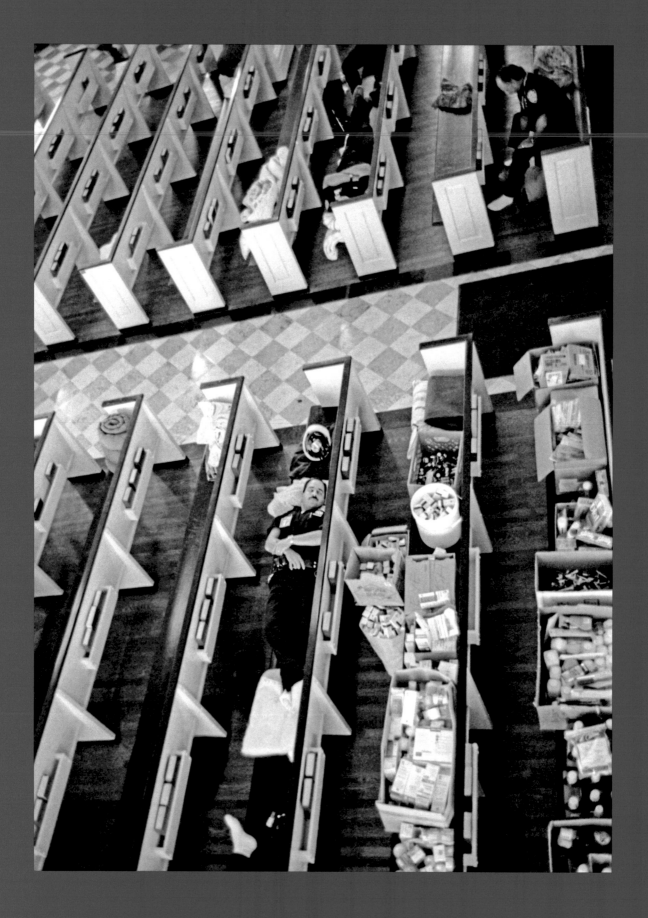

St. Paul's Chapel
New York City
Tuesday, September 25 1:30 p.m.

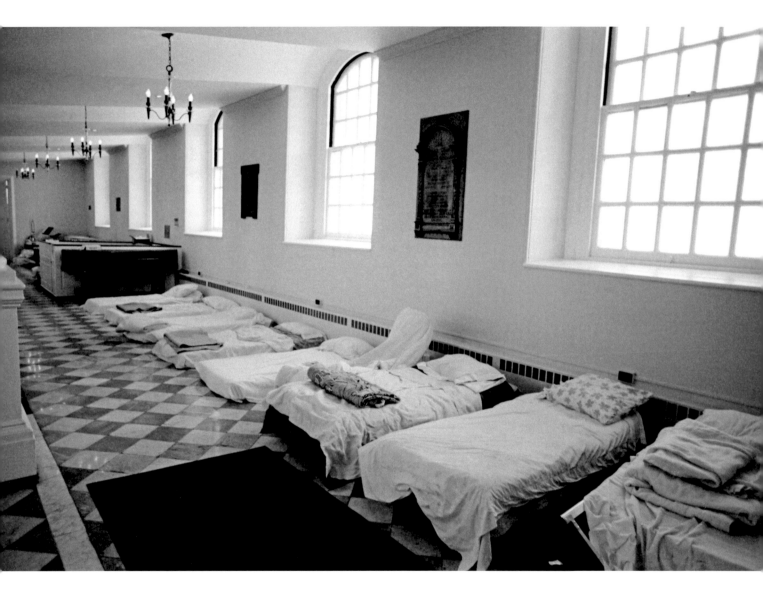

Empty Beds
St. Paul's Chapel, New York City
Tuesday, September 25 2:19 p.m.

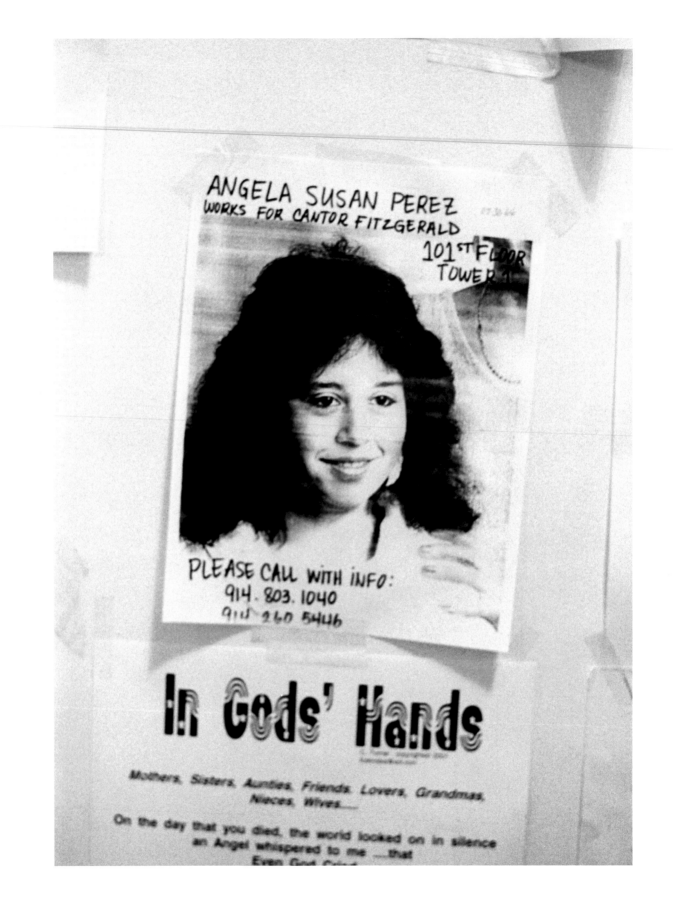

Grand Central Station
New York City
Wednesday, September 26 9:50 p.m.

Funding Your Own Assassins

Journal entry

September 1990

Montpellier, France

This afternoon has been remarkable and unsettling. After a few days here I have asked the young Muslim woman who runs the hotel if she would allow me to take her to tea so we can talk. I want to know what it is like for a Muslim woman to live here.

She is very different from what I expect though I'm not really sure what I expected. M, I will call her, is independent, proud and efficient. She wears modern clothing and no veil. She is outgoing, funny and bright. M speaks French, Italian, Arabic, and, luckily for me, perfect English. She also possesses a very healthy strain of dark humor, which I appreciate and I think my appreciation endears me to her just a bit. M patiently listens as I ask her about her parents and boyfriend.

"Is it difficult to remain a Muslim woman and to be independent?" I ask. Does she appreciate Muslim men and so on? My inquiry went on and, I suspect, was a bit tedious, but she kept her composure and answered my questions with a candor that startled me. I liked her and in a short time I began to respect her for all she had struggled with and overcome. She was the kind of person that you would want as a friend.

As I was about to ask more questions, she said, "I would like to tell you something. My observations about the West."

"Yes I would be very interested in your view of this country and the West in general," I said.

"You in Europe and America are so naive. You are sometimes to me like children and, at your worst, arrogant children. You think that you know the world. You not only do not know the world you make no effort to understand it even when you are threatened."

"What do you mean threatened?" I said.

"I came to France from Morocco where I had no chances like I have here. I did not wish to be a covered woman or someone's wife. I had dreams of education and my own business. I dreamed of a life where I was equal and where I could try and experience many things."

"But this is not a perfect place," I replied. "There is much prejudice here as there is in my country. Is that not a problem for you?"

"There is prejudice everywhere. My white French boyfriend of two years is still afraid to introduce me to his parents."

"That must make you angry."

"It frustrates me but it does not make me angry. I still have my independence and my dreams and I am in a place where some of them may come true and are coming true. But people like you do not understand the threat."

"That's the second time you've said threat. What

do you mean threat?" I repeated.

"You should be only letting people into your countries who are like me. People who want a new life, people who have dreams and want to be part of a free society. Instead you are allowing people into the countries who disrespect your way of life, have no respect for women or your laws, hate your religion and homosexuals and hope and work for your downfall. That is not very intelligent, is it?"

"Don't you think that is a bit extreme?" I replied.

"You do not know extreme. In the West you feel that you must be equal and kind to everyone though in practice that is just words. You want to feel righteous. But when you let those kinds of people in, they do not move in next to you, they live next to me and they try to reduce me to what they believe a woman's or man's place should be. You are not subject to the tyranny of these people, to their ignorance and hatred but I am. But whether you see it or not, it is only a matter of time before the confined disease spreads. You are all so foolish. You are funding your own assassins." –MK

Journal entry
26 September 2001
New York City

As I traveled the country photographing and talking with people from different walks of life, the American flag took on many symbols. For some it was a way to express their support for the country while feeling helpless. Others used it to intimidate those thought to be "different", and for those who were intimidated it was something to hide behind as if to say "I, too, am an American." In a number of stores the flag was used as a backdrop to remind people that it was patriotic to spend.

As I drove through the West and Midwest, I listened to Christian radio (sometimes it was hard to get anything else) and the demagogues who sounded like the extremist Muslims we were preparing to act against. In a small western town a woman wrote a letter to the local paper saying she agreed with the statements of Jerry Falwell. Most disturbing was the blind and grotesque patriotism that I witnessed outside of Chicago. It was the kind of patriotism that demands loyalty over conscience and always hastens a civil society's end.

To be sure, there were many rational and decent voices, too, like the WWII veteran who spoke to me at the "Breakfast Nook" in Rapid City, South Dakota. "We can never kill innocent people or take away people's rights," he told me. Even with some of those rational and thoughtful voices and the remarkable heroics of people here in New York and elsewhere, I came away from this trip unsettled. If we, as a country and a people, wish to honor the dead, then nothing will serve them or us as well as seeking and telling the truth, not only about the terrorists, but about ourselves.... –MK

1 December 2010

President George W. Bush
Crawford, Texas

Dear President Bush,

This is a letter I had hoped never to write, but in light of your recent public statements, I feel that I now have no choice.

On September 11, 2001, my wife, Dr. Kris Hardin, and I watched in horror as planes flew into the 'Twin Towers' in New York City. I spent the better part of the day controlling my anger and realized then, that it would be necessary, at some point, to respond to the attacks. I supported that view but with the caveat, that we first must be very clear as to who had planned and executed the deed and felt it essential that evidence be presented to the American people prior to any military response.

I had also hoped that we, and you, would be calm and thoughtful and not act to quickly or carelessly in the midst of national shock. I was equally concerned that there would be powerful forces in the country pushing for war, for a variety of reasons and interests, under the guise of patriotism.

At the time of the attacks, and for sometime thereafter, I was wishing you well and tried to understand and empathize with the pressures that you must be confronting and the multiple possibilities being weighed at such a momentous time. No matter the weight, however, I was still expecting from you and my government, sober, thoughtful and lawful leadership.

As time went on, I became increasingly disturbed by your careless words such as 'Bring it on,'" which I thought particularly unwise given that it would not be you in the line of fire. And then, during a journalist function, you made a joke of not finding 'weapons of mass destruction' which I found insensitive, cruel and indifferent. Sir, did you ever consider how, that joke, might be received by American and Iraqi families who had lost loved ones in the war?

My journal entry of 31 March 2007 expressed my concern;

While watching the news over the last few days, I have seen repeated clips of the White House Correspondents Dinner. There is the President telling jokes about subpoenas while the Speaker of the House laughs. I cannot tell if she is really laughing or being nervously polite. Then there is a clip of the President's main adviser and strategist, Karl Rove, being asked what he likes to do in his spare time. He answers that he likes to tear the heads off of small animals. I guess that is humor in the Bush White House. Then a hip-hop song begins to play and Rove starts to dance. The mc yells, "What's your name?" and Rove answers something like "Master Rove." All the while he is dancing and singing, a well-known television journalist is dancing behind him laughing and having a grand old time. Other people in the audience, including a number of prominent news people, are laughing and moving to the music as well. I cannot forget that while this bizarre party is going on Americans and others are dying in Iraq and Afghanistan and it all feels so unseemly, so profoundly immoral (a word I rarely use) and insensitive. As I watched this display, I wondered if any of the parents who had lost children in the war were also watching and if so what they thought. For even a moment did it cross their minds that their sons, daughters, fathers and mothers might have, just might have, died for nothing? I hope not.

I also wondered if when men were landing, killing and dying on Normandy, was Ike dancing the Tango some-

where safe and drinking with a bunch of scoundrels who in one way or another profited from the war. Watching the so-called journalists and power people drink, eat and dance, I realized that we are not in this together. I could not help but think of the estimates that have come out of Johns Hopkins University and the Lancet, which, estimates that nearly 600,000 Iraqi civilians have been killed. I don't know. People, of course, dispute those numbers and I understand. If I were responsible for that much death, I would also not want it to be true.

I thought about an Iraqi mother who had lost her son and what she would be thinking as the president joked and Rove danced and the journalists laughed. Maybe she would hate us, maybe forever.

The grotesque dancing continued as I recalled the pictures of the murdered Americans in Somalia and Iraq who had had their bodies mutilated and dragged through the streets as crowds cheered and yes, danced. Rove kept moving on the screen and try as I might I could not see a difference between either savages.

At some point I began to inform myself about your tenure as Governor of Texas and discovered that while in office, over 130 people had been executed in the state with the last being Mr. Claude Howard Jones. I found that on a number of occasions there had been media reports suggesting that you never spent more than ten to fifteen minutes reviewing capital cases. At the time, I found that reporting suspicious for surely, I thought, this could not be correct, for no one would be so cavalier with people's lives. Now I find that the DNA testing that was not done prior to Mr. Jones' execution has now been done and the result is that it is not Mr. Jones'

DNA. (Reported on NPR.)

These events began to suggest a long pattern of indifference, but still, I was trying to keep an open mind and explore all alternate possibilities for such conduct. Then came Abu Garib, Rumsfeld's "Stuff happens" crack, Katrina and, finally, the whiff of lies and torture.

Increasingly, I became uncomfortable with you first, as the leader of the United States, and then, with you as a man.

In London at a dinner party, I defended you somewhat as people questioned your intelligence. I immediately stated that I felt their criticisms were wrong headed and that what they perceived as a lack of intelligence was really indifference. It was at that dinner party that I first voiced what I had been feeling for a number of months previously.

I am the son of a soldier who, unlike you and me, saw the hell of war first hand and who had a profound distrust of people who promoted war but seemingly were never in, or near, the fighting. This point is particularly directed to Mr. Cheney who, throughout his career, has been such a person. His actions during your presidency have shown him to not only be a coward, but based upon his own words, a possible war criminal.

I have met with such thugs before in Hungary and Turkey, Morocco and Cuba as well as in France and England. They are all of a kind and can be found in all countries. These individuals are neither left nor right but rather a type of corporate amoralist whose 'only' allegiance is to 'More,' for themselves and their cronies at the expense of everything and everyone

else. Unlike you or Mr. Cheney I learned long ago that patriotism was more than the parroting of slogans or the wearing of a flag pin.

All of these cumulative actions started to suggest to me, that, perhaps you were not only an indifferent man but also a dishonorable one.

And now, I see you in an interview and you say in one breath, that you did give the OK for enhanced interrogation (torture) and then went on to say that you are content with your life and all that you have done. As a result of your statements, I have had to bridle my anger again.

A courageous and honest man would not come up with the not so clever 'newspeak' to disguise the reality of torture. He would call it as it is and then take responsibility for it but I have come to understand that you are not such a man. What you are, sir, as you have stated from your own mouth, is someone who gave the order to torture people in United States custody and you did that in my name and that I cannot let stand.

In Rumsfeld vs. Padilla, Justice John Paul Stevens wrote in his dissent to the court:

"....For if this Nation is to remain true to the ideals symbolized by its flag, it must not wield the tools of tyrants even to resist an assault by the forces of tyranny."

The coin of tyrants, throughout the ages, has been fear. And during your time as president, you, Mr. Cheney and others, used fear to such an extent that even today, friends whom I respect and trust say, after seeing this letter, to exercise caution and reconsider. They have said that you, and your hidden hands, could cause me misery and difficulties in addition to the serious difficulties that my dear wife and I now face. But I am not afraid of you. I am ashamed of you.

I thought it only right to contact you before writing to the International Criminal Court asking them to please begin an investigation concerning your and Mr. Cheney's admissions that you ordered torture on individuals in U.S. custody. I know that the ICC has no jurisdiction in the United States, but I feel that it is essential for some Non-American institution to involve itself in reviewing what transpired and where blame should be placed. To simply let your statements and actions pass without response makes a mockery of all that I have been taught that is fundamental to a decent and honorable society. I simply could not turn away.

Sincerely,

Michael Katakis

My True North

Kainkordu, West Africa 1988

Journal Entry
18 July 1988
Kainkordu, Sierra Leone

Today I watched as Kris held her namesake, Bondu Kris. It was such a gentle scene and as I watched I realized that I have never known anyone who possessed such a quiet kindness. There is an elegance about Kris that I find hard to describe and her understated compassion, especially with those most vulnerable in the world, is sincere and unconditional. It is beautiful, the most beautiful thing in the world.
–MK

Travel weary on one of a thousand trains 2004

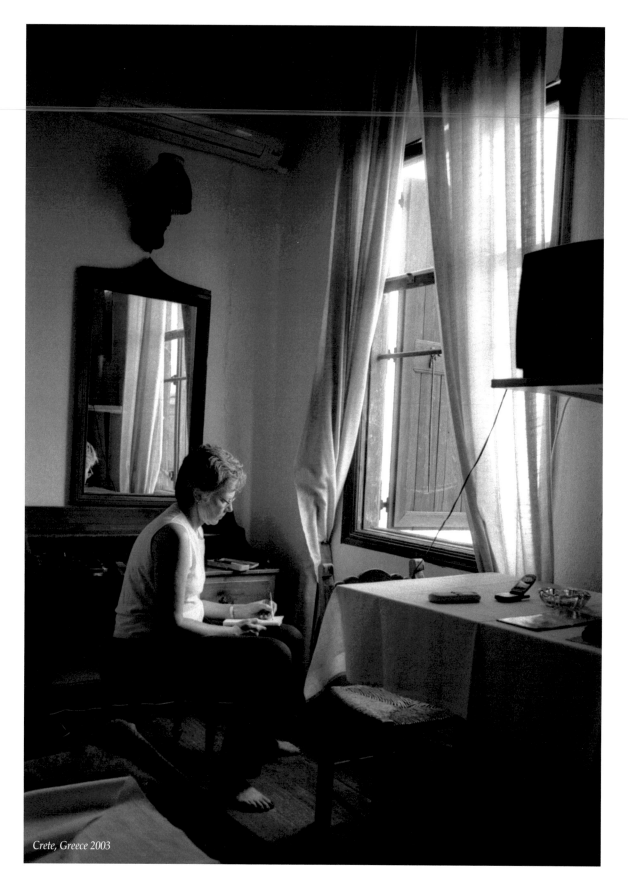

Crete, Greece 2003

Katakis / Hardin *Photographs and Words*

My True North

Journal entry

29 September 2003

Sounio, Greece

Kris and I have hiked up to the ruins of the Temple of Poseidon and the sea opens up before us. The breathtaking vista makes clear why the temple was built here. If Poseidon, the god of the sea, had lived anywhere he would have lived here. It is magnificent and we are gloriously alone with these ruins created some 440 years before Christ. Kris is sitting on one of the massive overturned columns as she opens her rucksack and pulls out the small watercolor box I bought for her in Paris years before. She is turned sideways and with her large sunbonnet and skirt, in silhouette, she looks like a traveler from another century in one of those old books that you would find in London. From the day I met her, I thought her the most beautiful woman I had ever seen. As a young anthropologist she had just returned from living in West Africa for years. Brains and beauty I had thought at our first meeting when I could not find the words, any words. She was kind as I stumbled. She has always been kind. As I watched her painting, I could not help but think of all of the miles we have traveled together since that first meeting, thousands of miles. I have learned much from her for she is always engaged in the world wanting to understand that which she does not understand. She is my center, my friend and my True North always guiding and welcoming me home. –MK

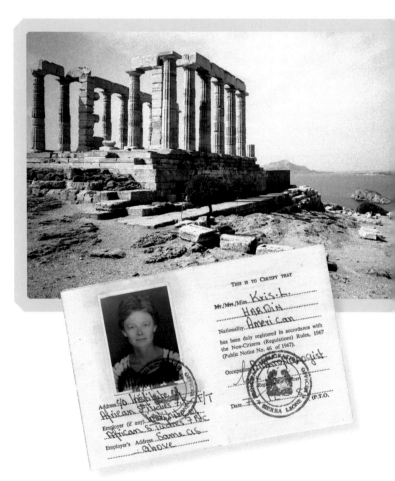

With friends Alan and Kati Lewis in France 2009

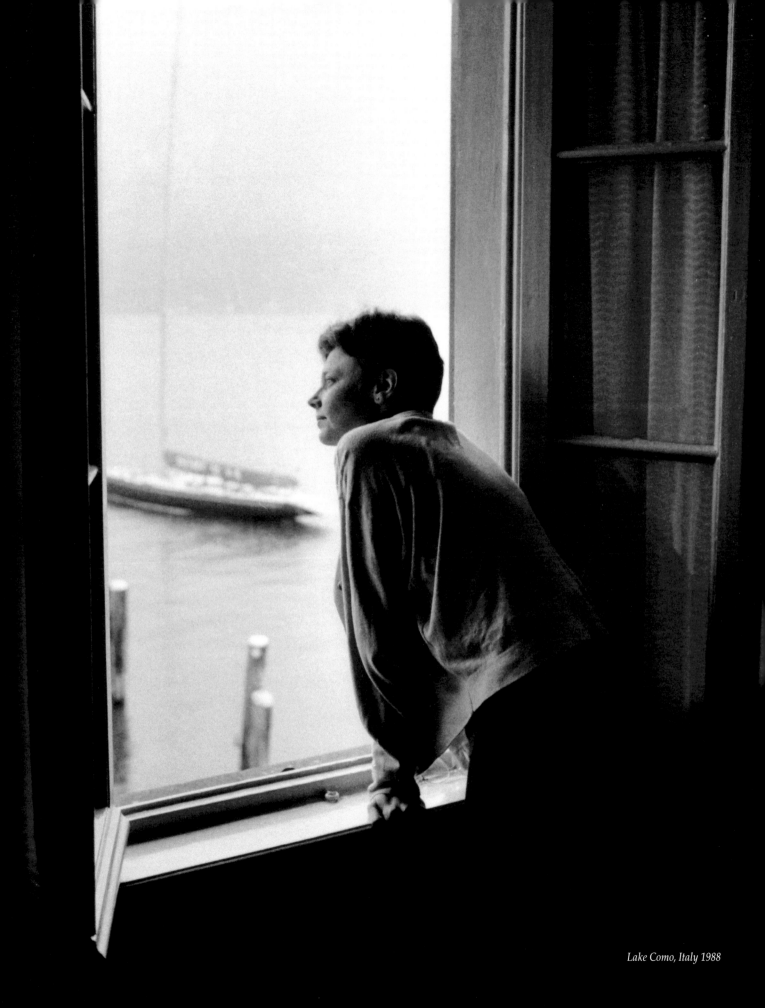

Lake Como, Italy 1988

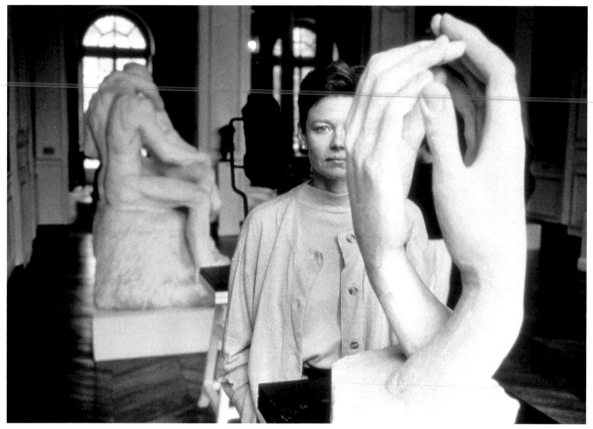

Rodin Museum 1998

Journal Entry
24 September 1988
Paris

I'm still very ill and continue to lose weight. Something from Africa will not let me go and I have no appetite, not even in Paris. Now that is a tragedy.

Kris got me out today and took me to the Rodin Museum. I turned to see her partially hidden face from behind a sculpture staring at me with concern. I think I just automatically took her picture. I know she is very worried but keeps up a good front. Catching her as I did tells me how hard all this is on her.
–MK

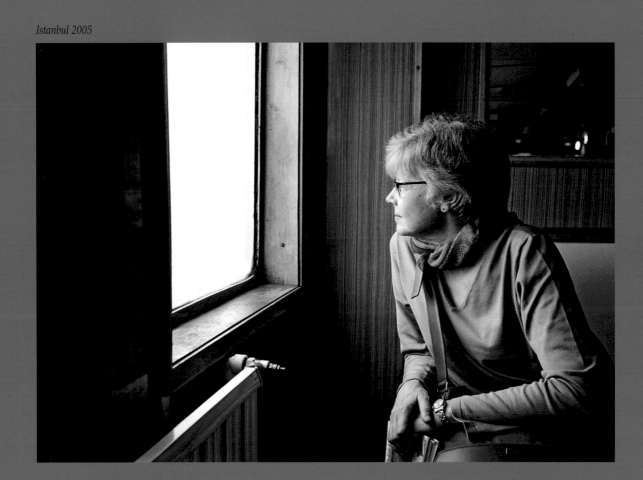

Istanbul 2005

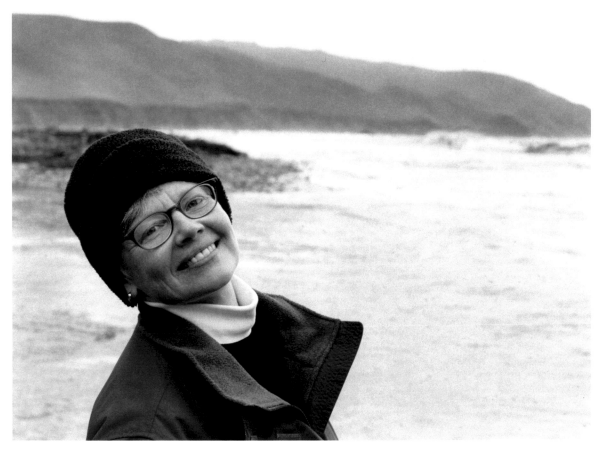

Big Sur, California 2006

Wheresoever she was, There was Eden

-Mark Twain

Acknowledgments

First, we would like to thank the remarkable and dedicated people at the British Library, in particular, Ms. Carole Holden, Head of American and Australasian studies. It was she who some years ago first expressed interest in acquiring Kris' and my work for the British Library collections and then made all things happen. Thanks also to John Falconer, Lead Curator, Visual Arts, and Marion Wallace, curator of the African Collection. To Kate Bower of the British Library Patrons Program and Mary Stewart of Oral Histories. Mr. David Way, Head of British Library Publications and Professor Philip Davies, Director of The Eccles Centre for American Studies. A warm thanks to Dr. Stephen Bury, formerly the Head of European and American Collections at the BL who is now, Andrew W. Mellon Chief Librarian, Frick Art Reference Library.

As Kris had told me on many occasions, after years of doing research, including at the British Library, that the people at the British Library were, and are, some of the finest curators that she had ever had the pleasure to work with. I have come to understand what she meant after working with all mentioned at the BL myself. In a world where knowledge and information is increasingly commoditized, there will be fewer and fewer places where information and original sources will be trusted. The British Library, with its dedicated people, is one of those rare institutions.

A thank you to our dear friend Michael Palin who has always offered his help and support and to his wife, Helen, who has always made a place for us at their table.

There are people who have stayed close to us during the difficult days that followed Kris' illness. They were always there and continue to be with a meal, kind word or attentive ear and with the unspoken promise that they would be there whatever the need. It is not possible to thank such people but Kris and I wish to at least acknowledge them here. They are, the ever positive and direct and loyal Lynn Badertscher and Tanya Johnson who is also the editor of this volume and the caring Wendy Ellis Smith. Jerry Fielder, Daniel Campbell and Ms. Barbara Stone who always has tea and time. The talented Alan Lewis and the elegant and always truthful Kati Lewis for being my (MK) Charlotte Shaw. To the dear gang in London, always, who are, Denise Prior, Julian Davis and Clare Gibson. Sarmi

and Michael Lawrence. Cherry Cole and Richard Fawkes. Thanks to Randell Bishop, Robert Boger and to our dear friend Cary Porter, who has always been there and his wife Gail. Dr. Peter English, Brian Spence and Belle Yang. Steve and Nancy Hauk, Jean O'Brien, Elizabeth Schneider and Toni Prepp.

Thanks to our dear friends Patrick and Carol Hemingway who altered Kris' and my life for the better. To Nataly Adrian, Nick Barnett, Hal Gurnee and Sean Hemingway for his kind words. To Kevin Hubley and Bratton Dubose, Susan Moldow, Jeff Wilson and Lydia Zelaya. Mary and Gerard Fort along with Laurianne and Celia. Karen Zander, Dewitt Sage, Marsha Shapiro and Kathleen Million.

To Lawrence G. Van Velzer and Peggy Gotthold of Foolscap Press for their constant inspiration and creativity. Susan Rubio, Colin Boyd (Lord Boyd of Duncansby) and Sandy Fold.

Raja Shehadeh, Peter and Carolyn Luff and Dr. David and Mrs. Betty Boyd. Denise Lyons, Hester Westley, Shirley Read, Eleanor Hardin, Douglas W. Hardin and Gore Vidal. Meredith May, Fred Hernandez and Seana Anderson of the American Trust for the British Library. A thank you to Mr. Gilles Morvan of the Ritz Hotel, Paris for his help and kindness and to Fr. Patrick McGeever (KH) for his friendship and enthusiasim.

We wish to thank everyone at Takigawa Design for their care and excellent work. They are: Jerry Takigawa, Jay Galster, Mary Wilson and Frank Chezem. To Ms. Natallia Fougeroud, Paris for all her kindness and help.

Thank you to Mr. Dennis High, the former curator and director of the Center for Photographic Art, in Carmel, California for believing in my (MK) work for a very long time.

A very special thank you to Ralph Starkweather who, years ago, told Michael Katakis that he should try taking some photographs and then for years after encouraged and advised. Without Ralph Starkweather's encouragement it is highly unlikely that Michael would have ever picked up a camera.

To the doctors and nurses who have cared for Kris. They are: The remarkable and humane Dr. Nancy Rubin. Dr. Susan Chang. Rene Jumbonville RN, Pauline Young RN, Dr. Andrew Parsa, Nicole Goldberg, Meiline Wong R.N., David Hoey R.N., Melia Talau Tonga. Dr. William Y. Hoffman, Dr. David Smith, Dr. Patrick Feehan and Dr. Theodore Kaczmar Jr.